# MIXED MEDIA
# PORTRAITS
## WITH PAM CARRIKER

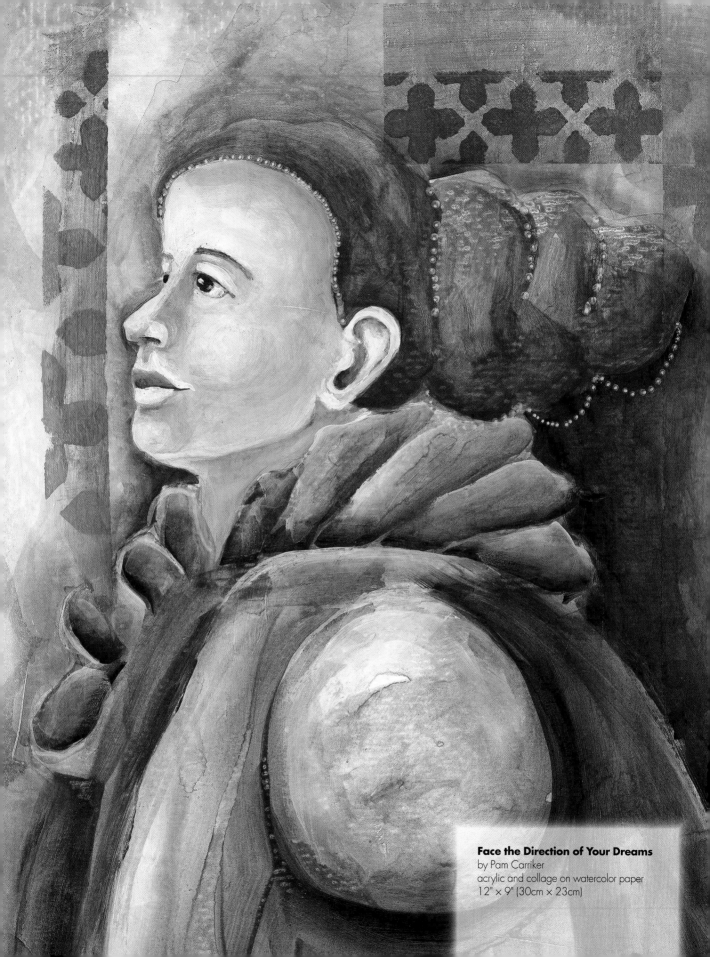

**Face the Direction of Your Dreams**
by Pam Carriker
acrylic and collage on watercolor paper
12" × 9" (30cm × 23cm)

# MIXED MEDIA
# PORTRAITS
## WITH PAM CARRIKER

## TECHNIQUES FOR DRAWING
## AND PAINTING FACES

**NORTH LIGHT BOOKS**
CINCINNATI, OHIO
createmixedmedia.com

# CONTENTS

# WHAT YOU NEED

## SURFACES

90-lb. (190gsm) or 140-lb. (300gsm) hot-pressed watercolor paper

140-lb. (300gsm) and 300-lb. (640gsm) cold-pressed watercolor paper

artist trading block cut from mat board or another block form

chipboard or sturdy cardstock

Fabriano Tiepolo printmaking paper

paper bags, 3

plein air panel

sketching/drawing paper of your choice

Strathmore Artagain black paper

Strathmore inkjet watercolor paper

Styrofoam wig form

Yupo paper, white

## PIGMENTS

acrylic inks

acrylic paints

alcohol ink

Caran d'Ache Neocolor II water-soluble crayons

Conté crayons

Enkaustikos Hot Cakes

Faber-Castell Big Brush pens

Faber-Castell Gelatos

Faber-Castell Pitt Artist Pens

gouache paints

Inktense blocks

Fluid Matte Sheer Acrylics

oil pastels

PanPastels

watercolors

## BRUSHES

1-inch (25mm) and 2-inch (51mm) flats

nos. 6 and 8 rounds

water-reservoir brush/waterbrush

## OTHER TOOLS

baren or plastic spoon, blending stump, bone folder tool, bookbinding needle, erasers (various), Fantastix tool, Gelli plate, iron or oven, journaling pens, lightbox, melting pot or hot plate, palettes (various), palette knife, pencils (various), Plexiglas or acetate sheet, Pronto-Plate polyester lithographic print plate, scissors, scraper tool, sgraffito tool, Sofft Tools palette knife and sponge tips, soft and hard rubber brayers, soft brush (corncob or other), spatula, sponge, spray bottles, squeegee, Stabilo All pencils, stencils, stylus, Thermofax screen, wax crayon (clear), Wipe Out tool or other blending tool, wood screen frame or embroidery hoop

## OTHER SUPPLIES

1-gallon (3.8l) plastic bag, alcohol blending solution or rubbing alcohol, baby wipes, black graphic chemical lithographic ink, CelluClay or other paper clay, cloth tape, collage materials, dry wax deli paper, embellishments, gesso, graphite transfer paper, India ink, inkjet transparency, liquid frisket, Liquid Pencil Sketching Ink, Matisse print paste, mesh-type material, Mixed Media Adhesive (or gel medium), open medium, painter's tape, paper towels, rubber gloves, sand-paper, Simple Green cleaner or SoHo studio wipes, Speedball drawing fluid and screen filler, waxed linen thread, Yes! or other paper glue

## OPTIONAL SUPPLIES

circle punch tool, citric acid powder, gum arabic, heat tool, Incredible Nib, liquid frisket remover tool, wax paper palette

5

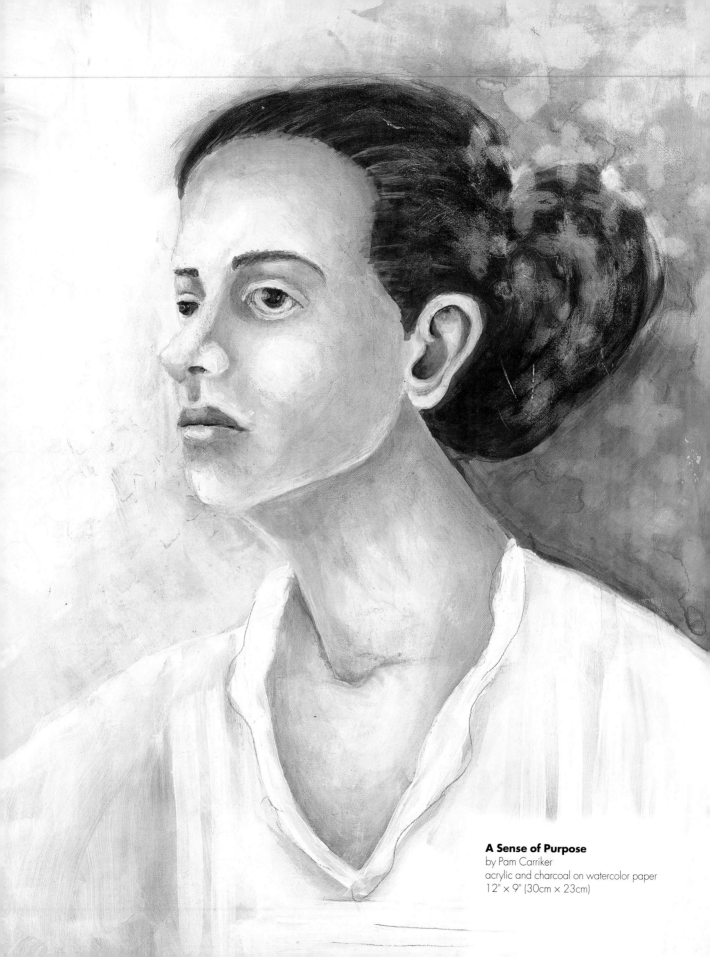

**A Sense of Purpose**
by Pam Carriker
acrylic and charcoal on watercolor paper
12" × 9" (30cm × 23cm)

# CHAPTER 1

# Purpose

I began my own Pursuit of Portraits back in 2008. Before that day, I'd randomly tried my hand at drawing and painting faces, but that day in 2008 I consciously made the decision to study the face. I began by picking up my sketchbook and putting time in every day. Regular practice is key to becoming good at anything. If you put the time in, you will see improvement.

Over the last few years I've noticed that improvement happens more rapidly when I do more quick sketches than when I spend more time on one sketch. It's like strength training in the gym: multiple repetitions using lighter weights = long and lean muscles. The same is true for sketching. Training your eye and hand to do the same thing over and over allows for a rapid toning of your sketching muscles. When you spend too long looking at a sketch, you end up erasing and redrawing and finding fault with your work, and that can lead to frustration. It also turns something that can be a relaxing activity into something that leaves a knot between your shoulder blades and may even cause you to lay your pencils down for good.

## WHY FACES?

Faces are such an interesting subject to sketch—you're never done learning about the human face. This is perhaps what is so intriguing about this subject and why so many are motivated to create them. I take many side trips where I study just the ear or eye or another detail and then go back to add those features to my faces. Because you look into the face of multiple people every day, inspiration is endless! You'll find when you begin sketching and using faces in your work that you notice the tilt of someone's head when you're talking to them or how the light is shadowing their face. The inspiration is literally staring you in the face each and every day.

## DISCLAIMER

This is not a book on fine-art portraiture, but rather a book showing easy ways to draw more realistic faces that can still have a stylized or signature look. With a minimal amount of time put in on a regular basis, you can build a body of work consisting of rough sketches that you can pull from to use in other mixed-media work. Most of the sketches shown in this book still have the face-mapping lines on them, and I created them using just one pencil. The goal is not finished portraits but a structure on which to build future work.

# EVIDENCE OF YOUR JOURNEY

I knew that if I put in the time sketching on a regular basis, I'd see improvement in my work. As I look back through my sketchbooks, the evidence is there. The evolution of those faces stares back at me from the pages, each one a building block for the work that followed. When people ask, "How long does it take to draw or paint a face?" the answer is those sketchbooks. Literally it takes mere minutes to sketch a portrait, but figuratively the years of practice contained in these sketchbooks hold the true answer to that question.

I have learned many things on my own journey, and I'd like to share some of them with you. Some of these things I did, and others are things I wished I'd done differently.

- Don't throw away your sketches even if you really don't like one. These are evidence of your journey, each a stepping-stone in the development of your signature style. I can't tell you how much I wish I had kept my sketchbooks from my youth and even into my adult life. I have a few, but I kept only things I liked, and that is not representative of my journey. So keep them all: the good, the bad and the ugly. They are your evidence, and one day you'll be able to look back and see how much you've grown!

- Use the same sketch multiple times to fully explore it and to strengthen your portrait skills. Tracing is a good thing! Tracing your own work builds memory into your artistic muscles. Do you like the eyes on one sketch, nose on another and mouth on yet another? Use a lightbox, the lightbox app for iPads or even a window to trace your favorite features from each of your drawings onto one face. Then you can practice tracing, drawing and building on that face.

- You can sketch from your imagination, from a photo or real-life object, or from a map or diagram, or incorporate a little of both your imagination and your reference.

This is my favorite method. You can also make maps from photos and then draw from those.

- One key to creating a look of your own is to add a bit of you to your portrait, making it a self-portrait of sorts. Take a facial feature you like or maybe even one that you don't like and incorporate that into your work. (The slight bump on the noses of some of my sketches is from my face, and not necessarily something I like, but it's me!) This puts your signature on your faces and helps you develop a look that is your own.

- Instead of getting hung up on making one sketch perfect, move on and create another. This is vital to moving forward. I don't ever spend more than half an hour and most times 5 or 10 minutes on a sketch. The time will vary from person to person based on how comfortable they are with a pencil and how much practice they've put in. When I'm done, I turn the page. Getting all caught up on one sketch, erasing and redrawing, can quickly spiral into frustration. Let your people be who they are meant to be.

- The last tip is simple: Draw. Put in the time, just a few minutes a day, and you will see improvement. If you want to draw faces, what are you waiting for? Grab a piece of paper and a pencil and begin!

**A Colorful Journey Ahead**
by Pam Carriker
acrylic and graphite on watercolor paper
12" × 9" (30cm × 23cm)

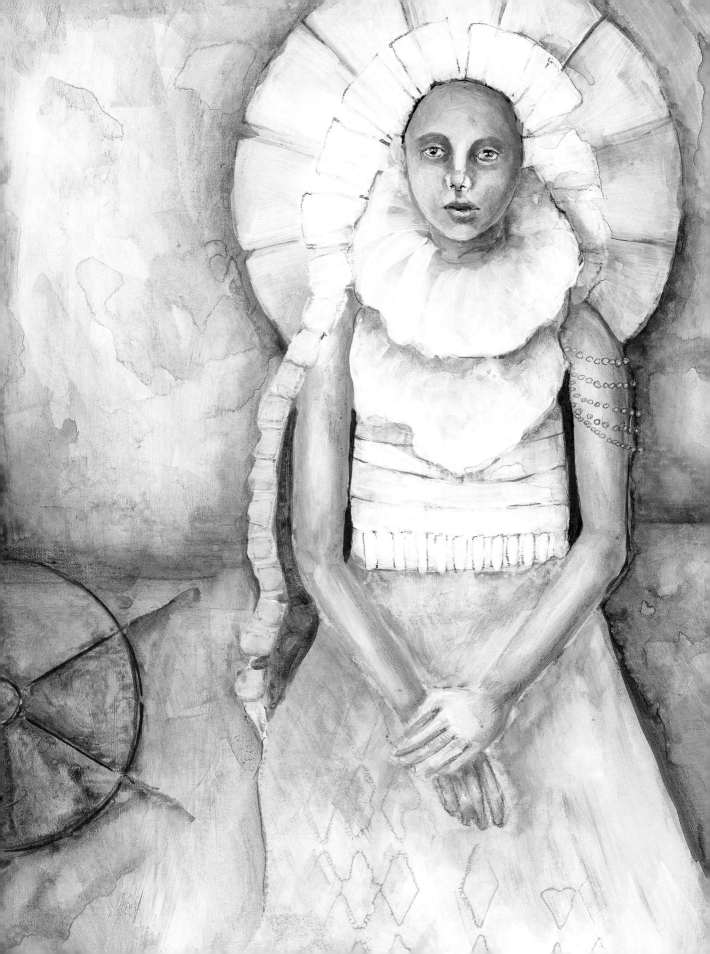

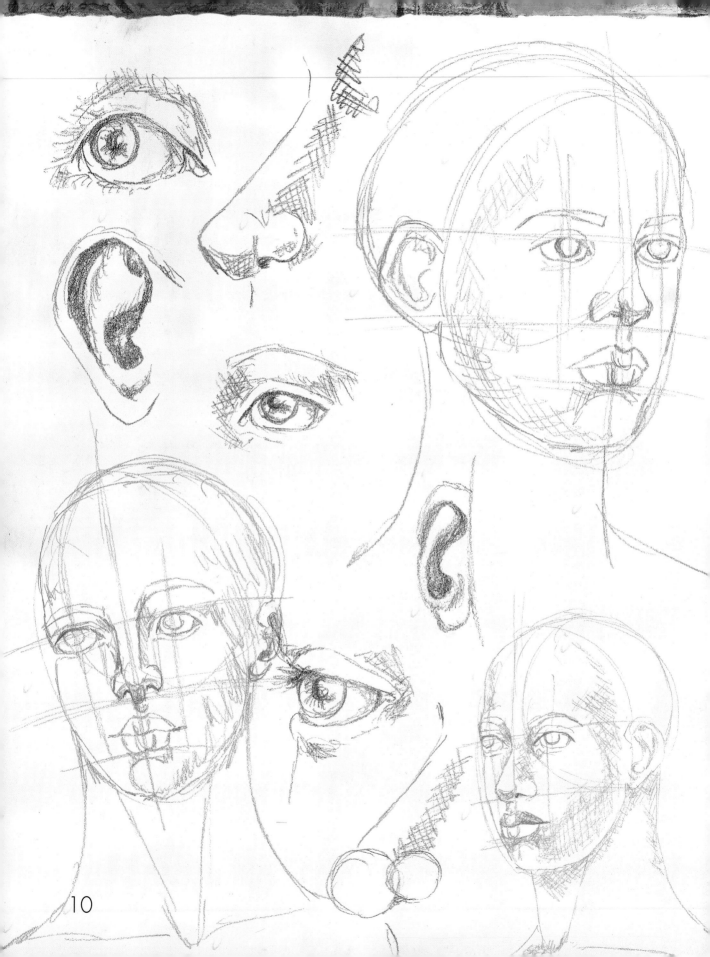

# HOW TO USE THIS BOOK

The purpose behind this book is to encourage you and help you create a continually growing body of rough sketches that you can use and reuse in your artwork. The face-mapping technique I use is easy to remember and allows you to draw a face anywhere, anytime, without needing a photo in front of you. You can draw faces from your imagination with a focus on creating a stylized look that is all your own.

Chapter 2 focuses on proportion. You'll see how this simple face mapping works and create some face maps of your own to practice sketching from. We'll discuss different angles of the head, head mass, face planes and more. You can also try your hand at the face details with some mini-demos showing easy ways to create each of the facial features using simple shapes or easy-to-remember tricks.

As you move on to Chapter 3, you will be guided through different ways you can bend the face mapping "rules" to create more stylized faces. This is where Pursuing Portraits becomes really fun! As you continue to create rough sketches, you'll begin to see growth in your own work, and, best of all, you'll create a body of work to pull from for the projects in Chapter 5.

In Chapter 4 you'll explore the color wheel, using a variety of mediums to create portrait palettes. This will get your own wheels turning as you begin to see the possibilities for future mixed-media projects with both ordinary and extraordinary color palettes and mediums.

Sprinkled throughout the book, well-known artists as well as a couple of outstanding students from my workshops will share their own portrait styles and answer questions about their pursuit of portraits to give you insight into their own personal journey. Their work is inspiring and will give you a broad range of styles to learn from. Look for the "Artists Share" pages to be inspired by their portraits and to learn about their experiences.

Chapter 5 is loaded with stepped-out mixed-media projects, where you can use your favorite sketches from Chapters 2 and 3 as the starting place. After all, this is the point of this book: Sketching daily is not an exercise unto itself; it is the basic foundation of painting and creating faces in your art.

**Inside My Sketchbook**
Here's a glimpse inside my sketchbook. Sometimes I concentrate on drawing a complete face, and other times I'll focus on one feature.

# KEEPING A SKETCHBOOK AND AN ART JOURNAL

In my first two books, I focused on keeping an art journal, a very important tool for any mixed-media artist. Now I'm saying you need to keep a sketchbook too? Yes, I am! The kind of sketching I'm talking about takes anywhere from 5 to 15 minutes a day. Really. It's not a finished-product kind of thing. It's comparable to taking notes rather than writing an essay. Often it's the only artwork I do just for me, and I look forward to it.

Keep sketchbooks stashed everywhere. I have them in my purse, on my nightstand, in my studio, on the kitchen table—really anywhere I may sit down for a bit and want to spend a few minutes doing something fun. I reuse these sketches in my journals as well as my other art projects. Even the bad ones can find a home in my art journal and morph into something cool.

Each face that emerges is like meeting a new person. They are who they are, and they don't have to be perfect. Each of us has facial features that set our face apart from everyone else's. We are unique and so are the faces we draw. Let them become what they become. Learn from each drawing and then move on to the next by turning the page. It can be tempting to rip out the sketches we don't like, but I encourage you to let them remain as evidence of your journey.

As you look for your sketching style, you'll want to pay attention to several things. Are you loose, edgy, soft, bold or something else? It's important to go with a style that might be emerging rather than fight against it. Sometimes it's easy to get caught up in learning from another artist as you try to make your drawings look like theirs. You can forget to embrace your own style as it emerges. Don't fight against it. Listen to it. Nurture it. Watch it develop. We aren't on this journey to make work that looks like someone else's. We are trying to find our own voice and distinctive look.

## MY FAVORITE SKETCHBOOKS

- **Moleskine Cahier:** These pages are nice for quick sketches, but thin enough to see through, with several tear-out pages at the end for tracing. They come in packs of three, making it easy to keep one stashed just about anywhere!
- **Moleskine Sketchbook:** Draw on only one side of the page to prevent ghosting or the transfer of graphite to the opposing page.
- **Strathmore Field Watercolor notebook:** Includes watercolor paper and drawing paper—great for mixed-media practice.

### Pencil Recommendation
For the sketches in this book I've used a 0.9mm mechanical pencil with a soft lead. This book is about creating usable sketches for mixed-media work and journaling, so most of the sketches are rough ones using only one pencil.

# ARTISTS SHARE: SKETCHBOOKS VS. ART JOURNALS

## DO YOU KEEP A SKETCHBOOK, AN ART JOURNAL OR BOTH?

**Violette Clark**

"I keep an art journal but not in the traditional sense. I art journal on loose pages of cardstock and keep them in a green box. I like being able to create on a clipboard and have that loose kind of freedom. I feel that sketchbooks are too confining. I used to create in an art journal book, but that was many years ago."
—VIOLETTE CLARK

**Katie Kendrick**

"I keep visual journals. I have several of different sizes; most of them are handmade or altered books (especially children's board books) that I work in. I do sketches wherever. I have some on scraps of paper I'll include in my journal as well as a few small ones that are all-purpose list/sketch/diary books."
—KATIE KENDRICK

"I keep an 'Idea Journal.' The drawings are not perfect and often having little notes written all around them to remind me of what I had in mind when the inspiration struck. I often don't remember what I drew the next day until I look. That tells me that had I not drawn it at that exact moment, the idea would have been gone forever."
—SUNNY CARVALHO

**Sunny Carvalho**

**Andrea Matus deMeng**

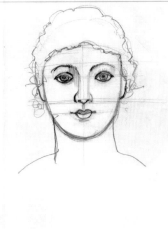

**Cindy Silverstein**

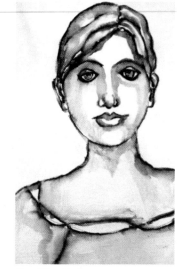

**Cynthia Stroo**

"I keep a sketchbook. I have one in practically every bag I own. I rarely leave home without one. I've tried journaling, but always end up sketching instead."
—ANDREA MATUS DEMENG

**Jane Spakowsky**

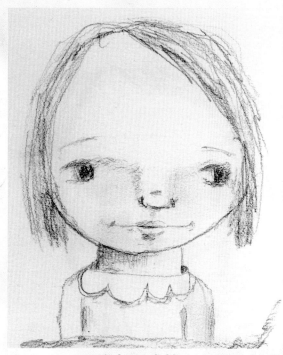

**Mindy Lacefield**

"I keep an art journal. I actually work on several at once to keep my perspective refreshed and to be able to step away. I am more comfortable with a brush in my hand than a pencil, so I don't necessarily sketch out my faces beforehand. Placement of the eyes and shape of the head do play a part in my girls, and when the inspiration strikes to play a bit, I will pick up a sketchbook to hash out the details."
—MINDY LACEFIELD

Visit CreateMixedMedia.com/Mixed-Media-Portraits for FREE bonus materials.

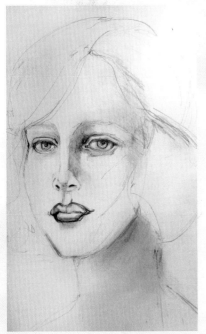

**Kate Thompson**

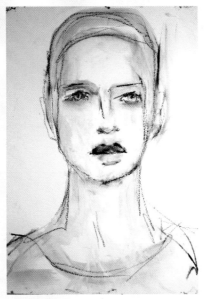

**Misty Mawn**

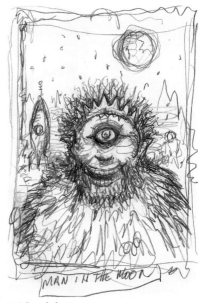

**Michael deMeng**

"I keep both. Sketchbooks keep me drawing, and that is by far the best discipline for artists. I have a journal, which helps me figure out techniques for paintings, but it is art only for me that I would never sell. It is my own artistic journey."

—KATE THOMPSON

"I keep a sketchbook. Sometimes my sketches are finished products and stand on their own; sometimes they are working designs for a final sculptural piece."

—MICHAEL DEMENG

**Traci Bautista**

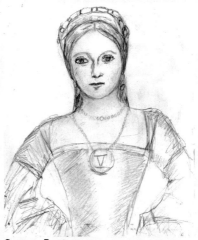

**Serena Barton**

"I keep a book with sketches, some writing, and images that speak to me from magazines or the Internet. Sometimes I keep a visual journal daily, and other times I may neglect it for months. When I do return to my journal, I wonder what took me so long."

—SERENA BARTON

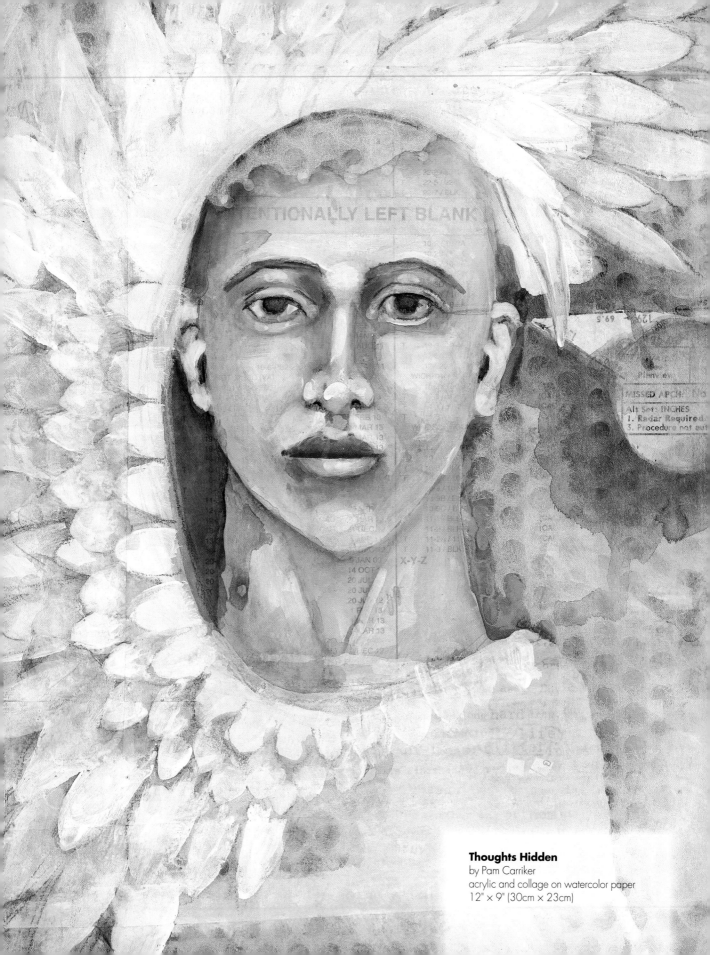

**Thoughts Hidden**
by Pam Carriker
acrylic and collage on watercolor paper
12" × 9" (30cm × 23cm)

# CHAPTER 2

# Proportion

Self-guided face mapping is a method of sketching that allows you to draw a face in generally correct proportions from your imagination. I've spent many hours simplifying this process to break it down easily to share with others. When I began my own pursuit, I didn't use any face-mapping lines. Then, when I found my work transitioning from "cute" flat faces to those with a more realistic look, I was studying the wide array of fine-art techniques and thought, "Wow, there must be a simpler way to get the look of realism but still retain a stylized look and not have to try to remember a bunch of rules." This book is my answer to my own search. It's what came from all of those hours of play and experimentation boiled down to an easy-to-learn process.

# SELF-GUIDED FACE MAPPING

What does that mean? Simply put, it means you can manipulate and control the size, shape and details of a face using two simple shapes and some basic, easy-to-remember guidelines to create faces from your imagination. This allows you total freedom to explore and develop a stylized look. It's freeing because you can draw faces anywhere, anytime, with no model or photo to work from. The face emerges from the guidelines, allowing you to see work that truly comes from within.

By using a circle to represent the head mass and an oval to represent the basic front plane of the face and positioning that oval around the mass, you can create front, side and three-quarter view portraits. You can also adjust the attitude of the head to upward tilt, downward tilt and anything in between. Simple and basic guidelines show how the facial features line up. They can be drawn freehand with no measuring—all you have to do is divide in half! This truly allows for each face to morph into its own and allows your style to emerge.

As you go through the stepped-out process in this chapter, keep in mind that your faces will not and should not look exactly like mine. I've tried to keep the faces very basic so they guide rather than distract you. It's important to listen to your own work. If your eyes keep coming out a certain way, try to work with it rather than fight it. This could be significant in developing your own style. Start simple, creating basic facial features at first if you aren't used to drawing faces. Don't get distracted by the work of others. Put those blinders on and focus on what your work looks like and build on it. Remember that artists who have a particular look to their work have most often put in many, many hours of practice for their styles to emerge.

## PENCILS AND DRAWING TOOLS

**Pencil leads** are classified by a letter or a letter plus a number. H stands for hardness, and B stands for blackness. The higher the H number, the harder the lead and the lighter the lines. The higher the B number, the softer the lead and the darker the lines.

**Blending stumps** are used to smudge, soften and move the graphite on the paper. They can be cleaned by wiping them on a scrap of paper or a chamois cloth and sharpened on a sanding block or sandpaper.

**Kneaded erasers** are self-cleaning and lift the graphite off the paper. You can control the amount of lift by the intensity of the pouncing. They don't leave eraser nubbies on your paper and can be cleaned by simply kneading them.

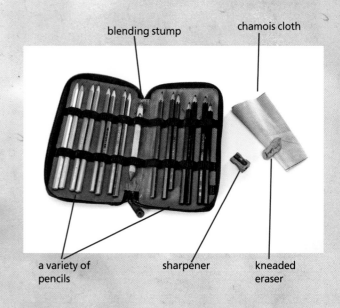

blending stump

chamois cloth

a variety of pencils

sharpener

kneaded eraser

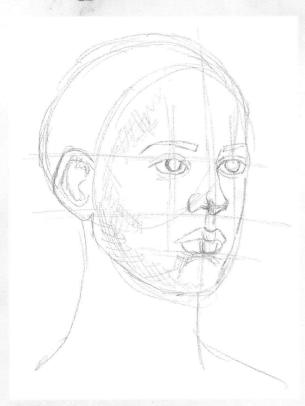

## Left Three-Quarter View

Here are the face-mapping guidelines for a figure looking to her left in three-quarter view.

## Three-Quarter View With Slight Downward Tilt

This image shows the face-mapping guidelines for a three-quarter view with a slight downward tilt to the figure's right.

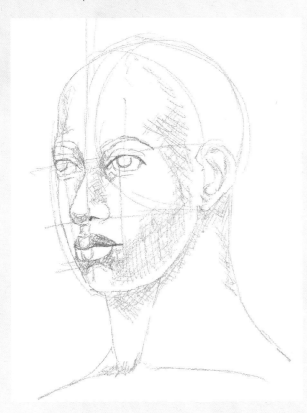

## Right Three-Quarter View

These face-mapping guidelines are for a figure looking to her right in three-quarter view.

# FACE MAPPING, FRONT VIEW

The front view of a face is usually the easiest to draw. The challenge is drawing symmetrical features that mirror each other. By mapping guidelines, you can easily place the features in the correct position. You can also measure the eyes, which can be tricky to duplicate, to make sure they are they same size.

## MATERIALS

blending stump (optional)
kneaded eraser (optional)
drawing/sketching paper
pencil

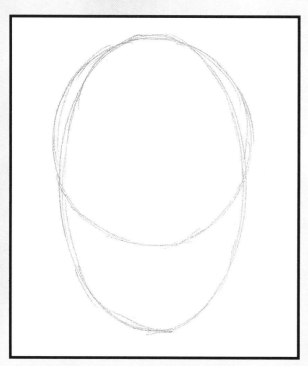

## 1 Draw a Circle and an Oval
Lightly sketch a circle and then an oval over the top of it so it's centrally aligned. Use short, sketchy strokes rather than trying to draw a perfect circle with one line. You're just establishing the head shape, and it will be altered as your sketch progresses.

## CHOOSING PENCILS

Hardest to softest, pencil lead grades include 8H | 7H | 6H | 5H | 4H | 3H | 2H | H | F | HB | B | 2B | 3B | 4B | 5B | 6B | 7B | 8B | 9B.

For sharp, crisp lines, a pencil with a higher H value lead is a good choice. Higher Hs are typically better for drafting purposes, and higher Bs are good for shading. Keep in mind that softer B pencils leave more lead on the paper and smudge much more easily than harder leads.

Some drawing pencils come with the shade of the graphite painted onto the pencil so it's easy to grab the right one without having to read those tiny letters and numbers. If your pencils aren't color coded, you may want to invest in an inexpensive pencil case to keep them in order so you can easily grab the right one.

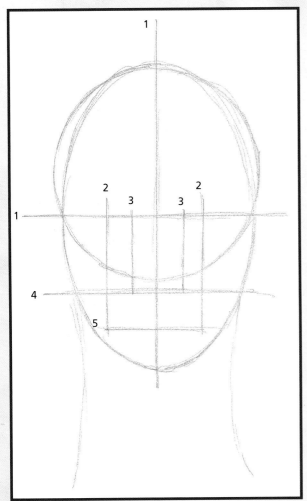

## 2 Divide the Face

Lightly sketch lines down the center of the face both horizontally and vertically (1). These are the midlines, your basic points of reference for drawing a face. You don't need to measure. Just use your eyes to judge the halfway points.

Sketch lines from the horizontal midline down to the bottom of the oval midway from the vertical midline on each side of the face (2). These eye lines show where to place the centers of the eyes. Sketch another line halfway between the line just drawn and the vertical midline (3). This line shows you the approximate width of the nostrils and the inside corner of the eyelids.

Sketch a horizontal line midway between the horizontal midline and the chin (4). This is the nose line. The nostrils and ball of the nose will rest on this line with the bottom of the nose dipping below it.

Sketch a horizontal line midway between the nose line and the chin (5). This will be the mouth line; the bottom of the lower lip will rest on this line.

## HOW TO USE PENCIL SETS FOR PORTRAITS

1. Draw the basic face shape with a 2H pencil. Adjust the head shape as desired. Shorter light strokes are easier to control.
2. Add face-mapping guidelines and facial details with light strokes of a 2H pencil so you can erase and adjust as needed.
3. Determine the light source and begin shading with light crosshatching using a 2B pencil. Use your lightest tone and set up the areas to be shaded.
4. Using a 4B pencil, add a darker value to the shaded areas. Make a few strokes, then blend with a stump.
5. Continue with progressively softer pencil leads to build darker areas, using less and less pencilling the darker you get.
6. Use a very sharp HB pencil to go back in and fine-tune the details.
7. Use a pencil eraser to create highlights. The kneaded eraser can also remove graphite and aids in blending areas.

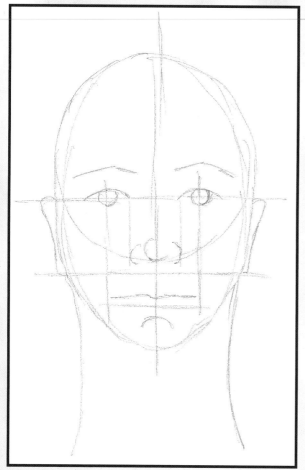

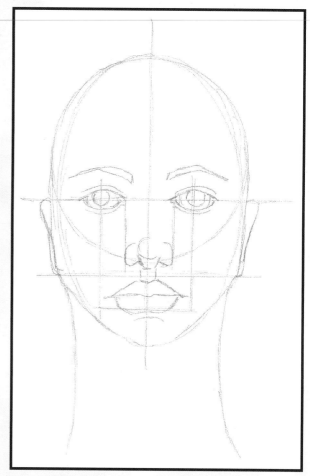

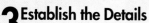

## 3 Establish the Details

Add small circles at the intersection of the horizontal midline and the eye lines. These will be the irises. Add slightly curved lines on top of the small circles, starting from the nostril line and extending an equal distance on the other side of the irises, to form the upper eyelids. The size should allow for roughly five of the same sized eyes across the face.

Add the ball of the nose and the nostrils to the nose line, staying between the inner eye lines.

Sketch the midline of the lips from one vertical eye line to the other, slightly above the lip line. Sketch the lower lip so it rests on the lip line.

Sketch the necklines starting from where the circle and oval intersect at the bottom of the circle.

## 4 Fill in the Details

Add eyebrows above the eyes. Add a crease line to the upper eyelid, then add the bottom eyelid. Draw a short line coming down from each nostril to form the philtrum (the vertical groove on the upper lip under the nose). Draw the upper lip with the bow of the lip peaking at each side of the philtrum.

Draw a hint of ears showing between the eye midline and the nose midline.

### EASY DIVISION

The math for dividing the face into sections is easy. You are always dividing in half. You don't have to measure, just eyeball it.

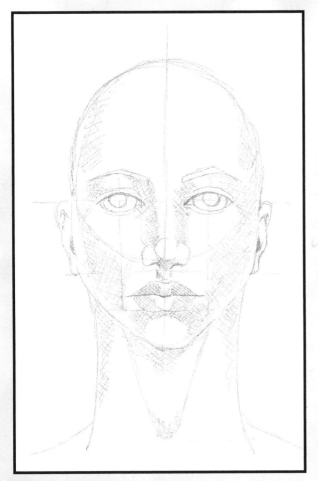

# 5 Add Crosshatching

Add crosshatching lightly with your pencil to define the shadow placement on the face. Make these marks by holding the pencil loosely and moving quickly around the face in one direction and then crossing over those lines in another direction. You may want to practice on a piece of paper to get the feel for it if you haven't done this before. (See Lights and Darks in this chapter for shading placement information.)

# 6 Blend and Lift

If you want a more finished look, use a blending stump in a small circular motion to blend out the crosshatching. Move the blending stump around the face, adding light touches of graphite with just what has been transferred to the stump.

If you get too dark and want to lighten things up, pounce with a kneaded eraser, lifting graphite from the drawing. When the eraser gets dirty, knead it a few times to clean it. You can also lift the guideline marks if desired.

# FACE MAPPING, SIDE VIEW

To make drawing the side view of the face easier, follow the arc of the oval's curve. This provides a guideline for the nose and chin placement. The eye is challenging at this angle. Remember that it's a ball in a socket, and you see the front curve of the ball from this angle.

## MATERIALS

blending stump (optional)

kneaded eraser

drawing/sketching paper

pencils

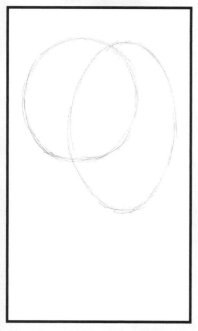

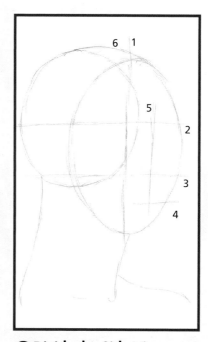

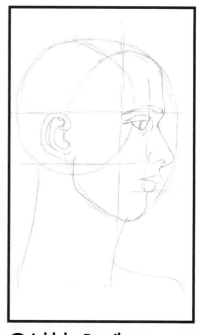

### 1 Circle and Oval Placement

Draw a circle. Then draw an oval to one side or the other, covering roughly half of the circle.

### 2 Divide the Side View

Draw a vertical midline dividing the oval in half (1). Next draw a horizontal midline dividing the circle in half to form the eye midline (2). Draw another horizontal line below the midline, dividing the bottom two-thirds of the oval in half (3). This is the nose line. Divide the face in half again below the nose line for the placement of the lower lip (4). Draw a vertical line dividing the oval in half again, marking where the side view of the eye starts and where the corner of the mouth begins (5). Using light, feathery pencil strokes, begin connecting the ball of the head to the oval, bridging the gap and continuing to cut down into the top of the oval, forming the forehead (6).

### 3 Add the Details

At the eye midline, indent the contour of the face to form the bridge of the nose, then continue outward to form the nose as you draw down to the nose midline. Note: the nose size can vary, but a good place to start is to have it touch the line of the oval.

Form the philtrum and the upper and lower lips, curving inward under the lower lip and back out again to form the chin. The ear placement falls between the eye and nose midlines, on the opposite side of the oval from the nose. The chin line continues up to the earlobe. The neck lines form behind the ear starting at the ball of the head and under the chin.

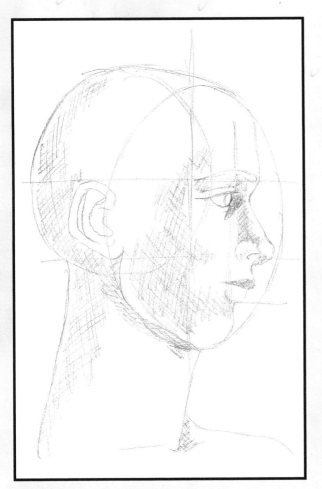

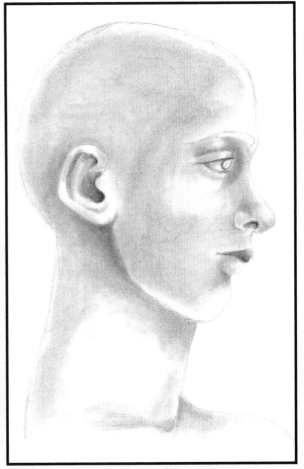

# 4 Add Crosshatching

Use crosshatching to add shading to the inside corner of the eye, the side of the nose, around the nostril, the philtrum area, the upper lip, below the lower lip and under the chin. You'll also want to shade inside the ear folds. (See the Ears mini-demonstration in this chapter for more details.)

# 5 Develop the Shading

If desired, you can use the blending stump to blend out the crosshatching and continue to work the shading of the face. Use the kneaded eraser to lift the guideline marks as needed.

# FACE MAPPING, THREE-QUARTER VIEW

This view may seem a bit daunting because the features are at an angle and require adjustments, but it's my favorite to draw. Mapping the face will guide you through the adjustments and feature placement. The circle and oval help to place the ear correctly.

## MATERIALS

blending stump
kneaded eraser
drawing/sketching paper
pencils

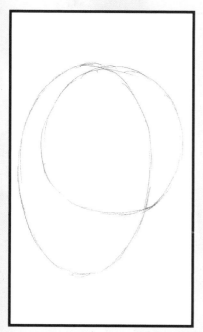

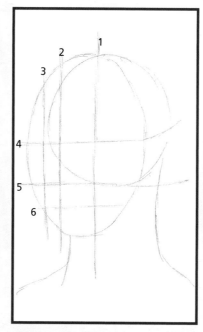

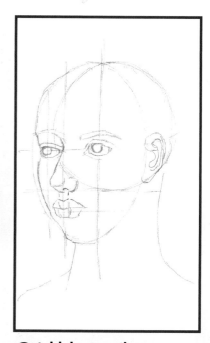

## 1 Circle and Oval Placement

Draw a circle. Then draw an oval on top of the circle to one side or the other, keeping the tops of both even with each other.

## 2 Divide the Three-Quarter View

Draw a vertical midline halfway between the side of the oval and the side of the circle (1). Draw another vertical line dividing the space between the side of the oval and the midline (2). Draw one more vertical line dividing the last section of the oval in half again for the other eye line (3).

Draw a horizontal midline through the circle for the horizontal eye line (4). Draw a line halfway down from that to form the nose line (5). Draw another line halfway down from the nose line to form the line the mouth's lower lip will rest on (6).

## 3 Add the Details

Add the eyes to the intersections between the horizontal and vertical eye lines. The pupils might not be exactly centered in this view, depending on the direction the subject is looking. Draw the eye shapes accordingly. Note that the eye on the side of the face that is showing the least will show less as it's tucked behind the nose a bit.

The nostril on the side showing the most in this view will line up with the inside corner of the eye, but the other nostril will show little, if at all. Both sides of the mouth will line up with the eye midlines in this view. The ear will fall between the horizontal eye and nose midlines and angle back slightly.

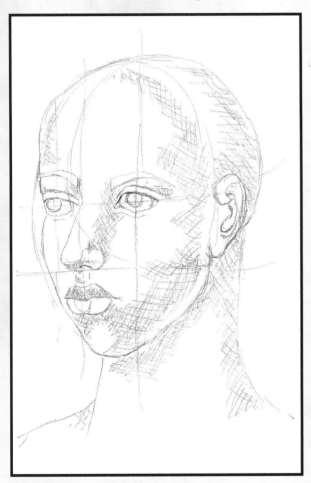

## 4 Add Crosshatching

Use crosshatching to shade areas such as the inside corners of the eyes, the side of the nose that is on the less visible side of the face, under the nose, under the lower lip and chin. Also lightly shade the more exposed side of the face along the jawline to establish the cheekbone area.

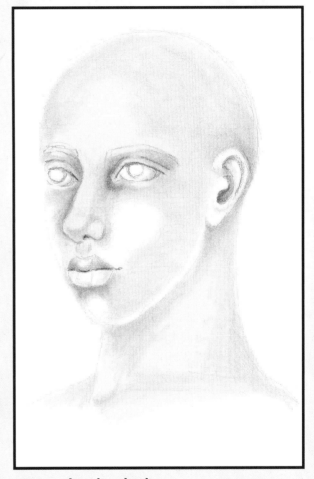

## 5 Develop the Shading

Continue on with the blending stump and kneaded eraser as in the other face views.

# FEMALE VS. MALE FACE FACTS

With just a few tweaks, you can easily go from drawing a female face to drawing a more masculine one. It's a fun way to stretch yourself, and, by using face mapping, you can draw a face without having a model to study.

I've listed some basic female and male differences on the front view and side view drawings here. Use the same face-mapping guidelines for both, adjusting the features for the masculine face.

**Female**

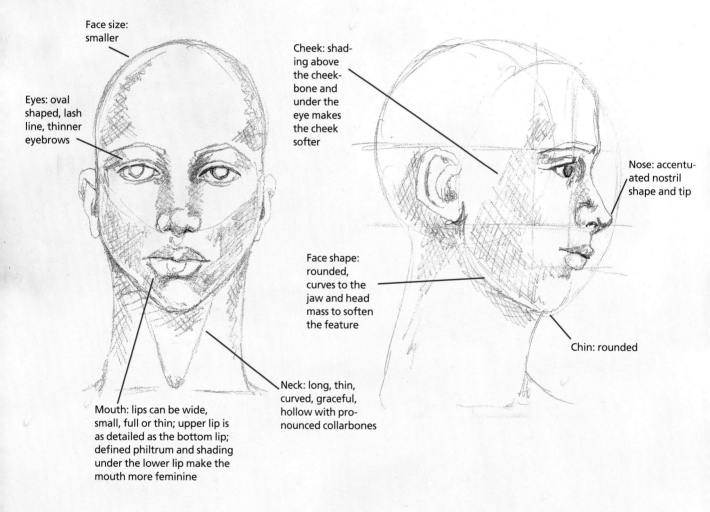

Face size: smaller

Eyes: oval shaped, lash line, thinner eyebrows

Cheek: shading above the cheekbone and under the eye makes the cheek softer

Nose: accentuated nostril shape and tip

Face shape: rounded, curves to the jaw and head mass to soften the feature

Chin: rounded

Neck: long, thin, curved, graceful, hollow with pronounced collarbones

Mouth: lips can be wide, small, full or thin; upper lip is as detailed as the bottom lip; defined philtrum and shading under the lower lip make the mouth more feminine

## Male

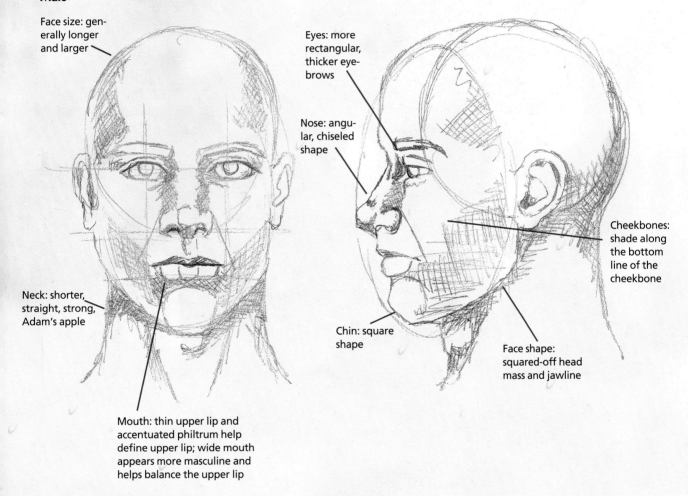

Face size: generally longer and larger

Eyes: more rectangular, thicker eyebrows

Nose: angular, chiseled shape

Cheekbones: shade along the bottom line of the cheekbone

Neck: shorter, straight, strong, Adam's apple

Chin: square shape

Face shape: squared-off head mass and jawline

Mouth: thin upper lip and accentuated philtrum help define upper lip; wide mouth appears more masculine and helps balance the upper lip

# THE TILT

By placing the oval in different positions to the circle, you can tilt the head in various directions. The ball of the head stays fixed, but the oval can move around it to allow tilted views. Play with positioning the oval and practice drawing additional views of the head.

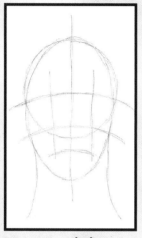 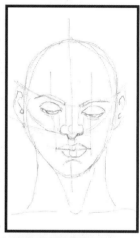

**Front Upward Tilt**
Note the way the horizontal lines curve slightly upward with the eyes just above the midline.

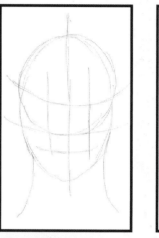 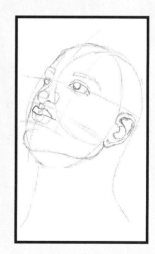

**Front Downward Tilt**
Note the way the horizontal lines curve slightly downward with the eyes just below the midline.

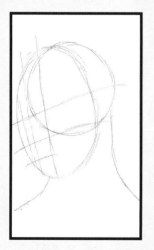 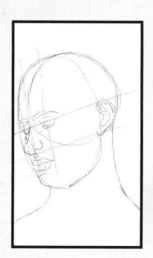

**Three-Quarter Downward Tilt**
Note the direction the eyes are looking.

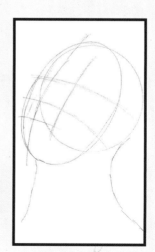

**Three-Quarter Upward Tilt**
Note that the pupil of the eye is not centered on the eyeball, but more of the white is showing.

30

# MAPPING YOUR SELFIE

Selfies are great tools for anyone interested in drawing faces. Whenever I need to see how a feature looks, I take a selfie to work from. That's the great thing about studying the face—you always have a model! Normally, I'm only checking how the features line up rather than actually drawing my face, but it is fun once in a while to attempt a likeness of yourself.

Think, "WWFD?" (What would Frida do?) Frida Kahlo devoted much of her art to doing self-portraits, emphasizing that famous unibrow and mustache. Don't be afraid to emphasize your "flaws" or exaggerate something you like or don't like about your face. This is a fun exercise to do wherever you are, as you'll have all the tools you need if you remember to carry that sketchbook and pencil with you.

## MATERIALS

drawing paper

lightbox (optional)

pencil

phone camera

printer and copy paper

red pencil

## 1 Take and Print a Photo

Take a selfie with your phone camera on a black-and-white setting. Try a fun angle that represents the true selfie style of portraiture.

Print the photo on regular copy paper at the size you want to work with.

## 2 Map the Face

Use a red pencil to map your facial details directly on the photocopy.

## 3 Transfer the Face and Draw the Details

Trace or transfer the map into a sketchbook using a lightbox or another transfer method.

Draw the details on the map using the photo as a guide. Remember, your sketch doesn't necessarily have to look like you. It's representational. Use as many of your face details as you like.

# LIGHTS AND DARKS

Establishing very light and very dark areas in your portraits helps the face to pop. The key is to use small amounts of each, letting the midtones do the bulk of the work defining the face. It's easy to get carried away with the dark-dark areas, so remember a little goes a long way.

The diagram below shows the key areas that should be highlighted or shadowed. This is a basic face that has light hitting it straight on. As you continue to draw, you can play with your light source, having it hit from different directions. Having a basic understanding of where highlights and deep shadows occur on the face will help you draw from your imagination when no model or photo is present.

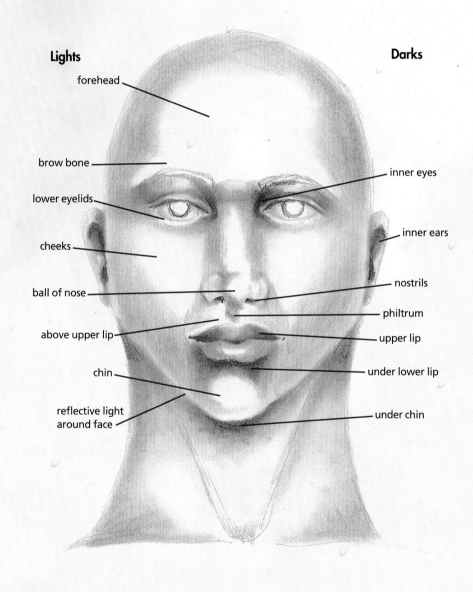

**Lights**
- forehead
- brow bone
- lower eyelids
- cheeks
- ball of nose
- above upper lip
- chin
- reflective light around face

**Darks**
- inner eyes
- inner ears
- nostrils
- philtrum
- upper lip
- under lower lip
- under chin

# HEAD MASS

The ball or back of the head shape is the cranial mass, and the triangular shape formed by drawing a line from the bridge of the nose to the jaw hinge is the facial mass. There is a lot to learn about head structures, but in my journey I wanted to know the basics and find easy ways to represent them for correctly proportioned portraits. I simply use a circle to represent the cranial mass and an oval to represent the facial mass.

Often when drawing faces in mixed media, artists tend to treat the whole head as one shape, usually an egg shape, rather than two separate shapes, which is a more realistic approach. Treating the head mass as a sphere and an oval helps you create a head rather than just a face and adds so much more dimension to your work. It's not as complicated as it seems, and you don't need to get into great detail. Remembering mass and working around it will help you create more realistic faces.

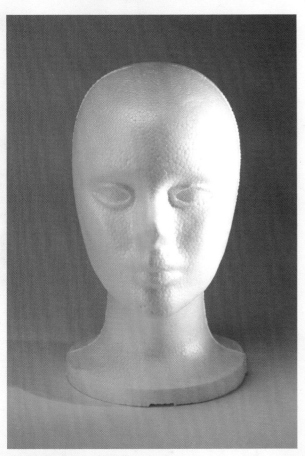

**Finding the Planes of the Face**
Using a Styrofoam wig form and light can help you capture the planes of the face with the light coming from different sources. It's an inexpensive tool and can easily be found online or at a beauty supply store. Just set the wig form under a light and study how the light hits the planes of the face.

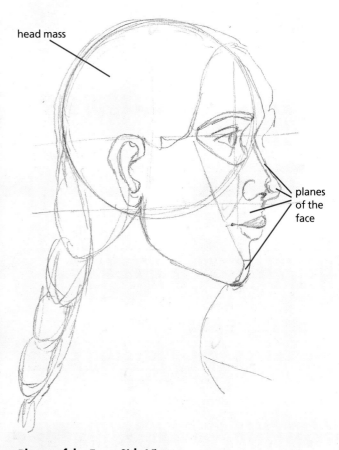

**Planes of the Face, Side View**
This sketch shows the head mass or ball of the head and some simple face planes from a side view.

# FACE PLANES

Recognizing some of the planes of the face (the areas that catch the light) is helpful when drawing and painting more realistic faces. This can be a complicated process, so I've broken it down into some basic steps to give you a good reference that is easy to work from.

## MATERIALS

blending stump (optional)

kneaded eraser (optional)

drawing/sketching paper

pencils

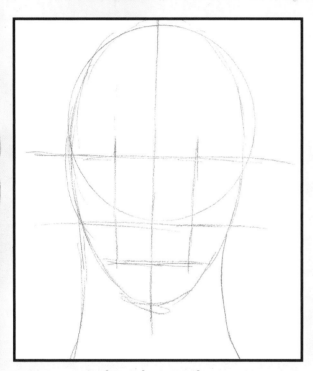

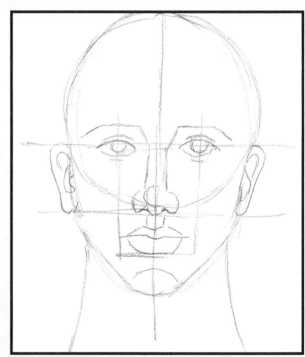

**1 Draw a Circle and an Oval**
Sketch the basic circle and oval to form the front view of the face.

**2 Add the Basic Face-Map Lines**
Draw the front view face-map lines and face details (or you can copy one of your front view sketches and work from that).

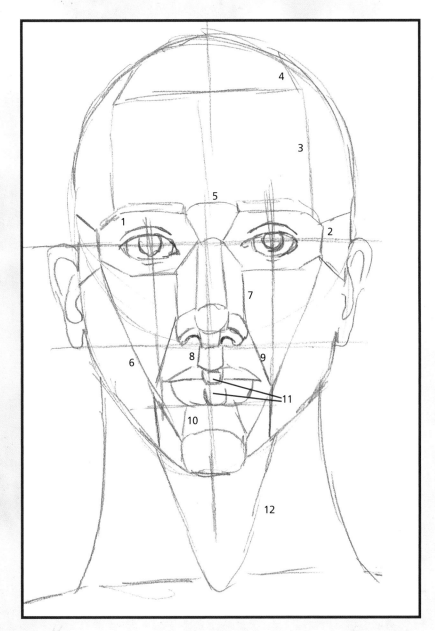

## 3 Continue Mapping

Using short, straight lines, enclose each eye area with an octagonal shape bordered by the eyebrow and the bridge of the nose (1). Draw two lines that splay out a bit from the side of each eye socket shape (2).

Draw two lines up from each side of the eyebrow, not quite to the top of the head, to form the rectangular forehead plane (3). Draw two lines angling inward from the top of the forehead plane to the top of the head (4). Connect the inside of the two eyebrows to form the bridge of the nose (5).

Draw a line from the lower end of the outside straight edge on each eye area to the ball of the chin area to form the jaw plane (6).

Draw a line down from the inside lower edge of the eye area to the nostril on both sides of the nose (7). Draw two lines on each of the nostrils that connect the area underneath the ball of the nose (8). Draw a line from the top of the nostril to the midline of the mouth on both sides that will intersect with the jawline (9).

Draw a line from the bottom of each side of the lower lip to the ball of the chin (10).

Draw a simple U shape in the middle of both the upper and lower lips (11). Draw a V shape that starts about where the midline of the mouth is, beginning underneath the neck to form the column of the neck and the hollow of the throat (12).

# EYES

All eyes have the same basic sphere shape, but the upper and lower eyelids vary from face to face and determine the appearance of the eyes. The face is roughly five eye widths wide, and there is one eye width between the eyes. Start simply and then branch out with different looks as you study photos and faces.

## MATERIALS

blending stump

drawing/sketching paper

pencil

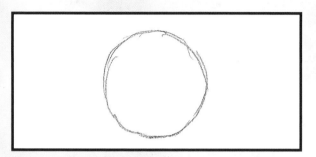

**1 Draw a Circle**
Start by drawing a circle.

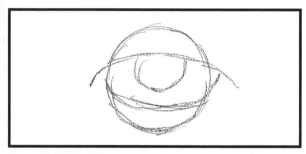

**2 Add the Iris, Pupil and Lids**
Add an iris and a pupil to the middle of the circle. Draw upper and lower eyelids. These may partially cover the iris.

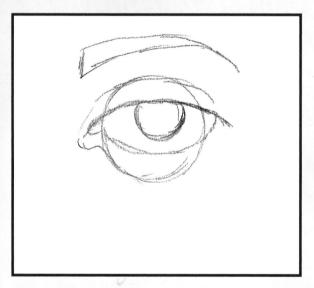

**3 Continue Drawing the Lids and Brow**
Extend the curve of the upper part of the original circle to form the crease in the upper eyelid. Do the same with the lower part of the circle to form the lower eyelid.

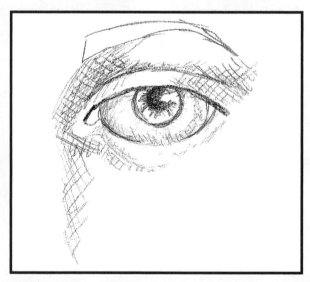

**4 Add Crosshatching and Shading**
Outline the light reflections on the eye and darken the pupil with a pencil. Use a blending stump to move some graphite around the iris, to help shape the eyeball and the eyelids.

Add some pencil marks to the iris and some eyelashes if desired. Draw in the eyebrow.

# EYE VARIATIONS

Here are some examples of different eye shapes and angles and how they can affect the expression of the portrait. It's fun and a great exercise to do a study of one feature, like the eye, and practice drawing it in different perspectives. You can use these studies for future reference material.

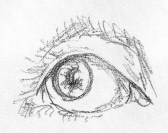

**Right Eye Looking Up**

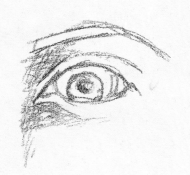

**Left Eye, Three-Quarter View**

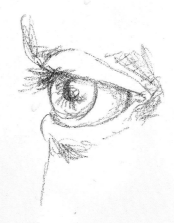

**Right Eye, Three-Quarter View**

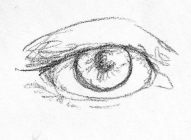

**Calm Eye, Front View**

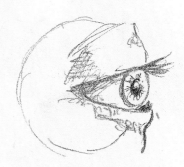

**Startled Eye**

**Eyeball, Side View**

# EARS

Ears can be a bit intimidating, and many artists use hair to cover them up, not attempting them at all. But with a little trick and some practice, ears themselves can be a fun drawing subject!

The ears are located between the eye midline and the bottom of the nose. The width of the ear at its widest point is roughly half of its length. In profile view, they are placed on the side of the head, measured from the outside corner of the eye to the outer fold of the ear, a distance equal to the distance between the outside corner of the eye to the chin. To draw the ear, think of it as a question mark with a lowercase y inside. This will help you remember how to draw all of those intricate inner ear folds. Try taking a picture of your own ear to work from.

## MATERIALS

drawing/sketching paper

pencil

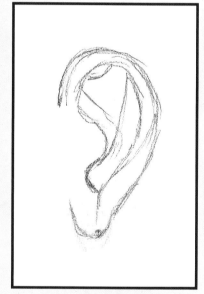

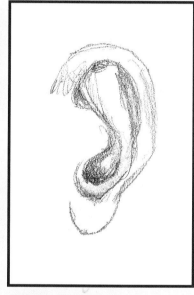

### 1 Draw the Basic Shape
Draw a question mark with a lower-case y inside.

### 2 Develop the Form
Add the outer line of the ear and lobe. Thicken the question mark to form the inner ear. This will be highlighted.

### 3 Add Shading
Shade the ear canal and around the inner ear folds.

# EAR VARIATIONS

Depending on the angle of the head, the ear's appearance changes. Here are some samples of various ear shapes and angles. I often take a picture of my own ear with my phone when I want to see what it looks like at a certain angle, and then I draw from the photo.

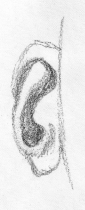

**Right Ear, Front View**

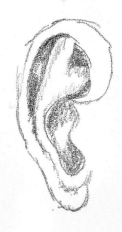

**Right Ear, Side View**

**Right Ear, Three-Quarter View**

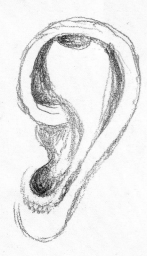

**Left Ear, Side View**

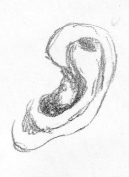

**Left Ear, Side View With Upward Tilt**

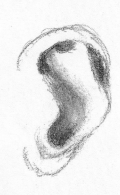

**Left Ear, Three-Quarter View**

# NOSES

You can create a variety of noses by simply using circles. Depending on the position of the circles, you can create distinctive looks. In general, the bottom of the nose is one eye width (the edges are straight down from the tear ducts on the face map). Small adjustments can have big effects, so play around to find a nose that fits your face.

## MATERIALS

drawing/sketching paper

pencil

## FRONT VIEW

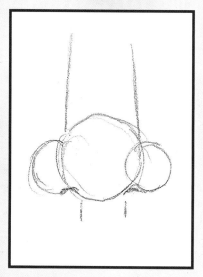

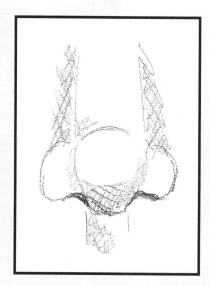

### 1 Draw the Circles
Draw a center circle (ball of the nose) and two smaller circles, one on each side of the central one, overlapping it. By moving the nostrils up and down you can create different noses.

### 2 Add Shading
Add crosshatching to each side of the nose, on the underside of the ball of the nose and to the philtrum area. Darken the nostrils, being careful not to make the shading circular.

## THREE-QUARTER VIEW

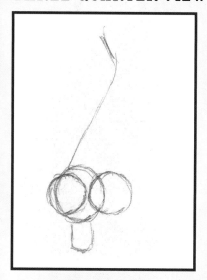

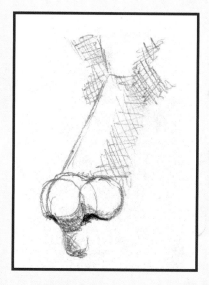

### 1 Draw the Circles
Draw a circle (ball of the nose) and two smaller circles, one almost completely overlapping the ball (this will be the nostril on the side of the face that you don't see) and one barely overlapping the ball of the nose.

### 2 Add Shading
Add crosshatch shading to the eye socket areas, the side of the nose that's showing, under the ball of the nose and the philtrum area. Darken the nostrils.

# SIDE VIEW

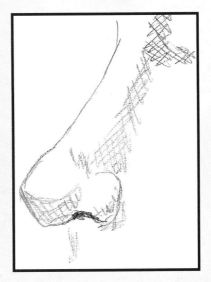

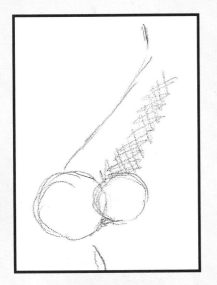

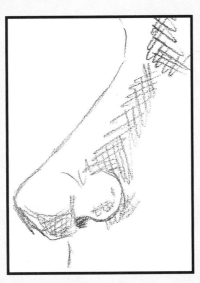

## 1 Draw the Circles
Draw a circle and then draw one smaller circle to the side of the first one. You can move this circle up and down to create different noses.

## 2 Add Shading
Shade from the nostril upward on the side of the nose.

### Nose Variations
By placing the nostril (small circle) in a slightly higher position, you can easily change the look of the nose a bit. You can try placing the nostril circle(s) in various positions to the ball of the nose (large circle) to create a variety of noses.

MINI-DEMONSTRATION
# MOUTHS

The mouth can also be created with simple circles. By overlapping the circles differently, you can create all three views of the mouth. Some things to note about the mouth: The midline should extend a bit past the upper and lower lips on either side. The upper lip is usually wider and darker (more shadowed) than the lower lip, which catches the light. The lower lip is often formed more by the shading underneath it than by actually shading the lip itself.

## FRONT VIEW

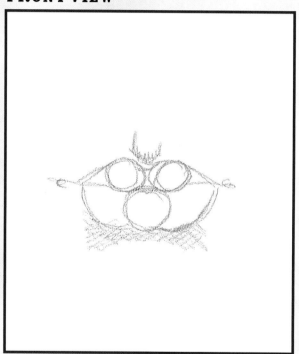

### 1 Draw the Circles and Lines
Draw two circles side by side. Draw a third circle under the top two and centrally aligned with them. Draw a midline. Draw contours around the upper circle to form the upper lip. Draw around the bottom circle to form the lower lip.

### 2 Add Shading
Shade the upper lip darker than the lower, and shade under the lower lip.

# THREE-QUARTER VIEW

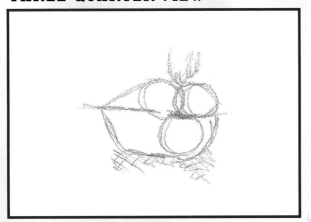

## 1 Draw the Circles and Lines

Draw two circles slightly overlapping to form the upper lip. Draw a third circle under the top two and centrally aligned where they overlap. Draw the midline of the mouth extending farther out one side (right side of the mouth) and one just past the upper circle (left side of the mouth). Draw contour lines around the upper circles to form the upper lip and around the bottom circle to form the lower lip. Remember that you are seeing only part of the right side of the mouth and all of the left side.

## 2 Add Shading

Shade the upper lip darker than the lower lip, leaving a highlight in the middle. Shade the lower lip, leaving a highlight in the middle, and shade under the lower lip.

# SIDE VIEW

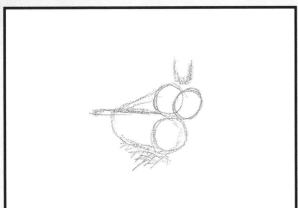

## 1 Draw the Circles and Lines

Draw two circles overlapping in the middle to form the upper lip. Draw a third circle underneath the left upper circle. Draw the midline from the upper right circle extending it past the upper left circle to form the side view of the lips. Add contour lines to the upper and lower lips.

## 2 Add Shading

Shade the upper lip darker than the lower lip. Leave a highlight on the right side of the lower lip and lightly shade the rest. Shade underneath the lower lip.

# FACE MAPPING FROM A PHOTO

Face mapping from a photo is a great way to strengthen your portrait skills. I love this photo of Virginia Woolf, especially her hair, and I wanted to play around using it for inspiration. I first used the photo to make a face map to sketch from, and then I decided to paint her as well. The important thing to remember with this kind of portrait is that it doesn't have to look exactly like the photo; use the photo for inspiration. You can see how I changed her nose to look more like the images I draw, but I loved her hair and dress, so I kept those the same. In the painting I took more liberties and added stenciled images as well.

## MATERIALS

blending stump
copy paper
drawing paper
glue
kneaded eraser
lightbox
paints of your choice
pencils, assorted
printer
red pencil
reference photo

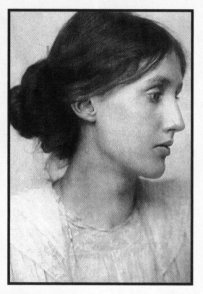

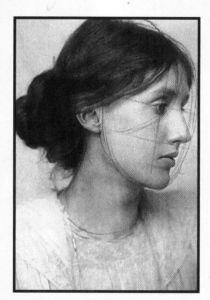

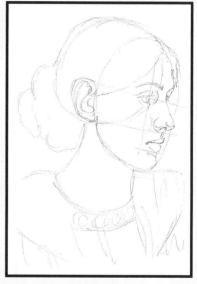

**1 Print a Photo**
Print the photo out in black and white on regular copy paper.

**2 Map the Face**
Use a red pencil to draw a map on top of the photocopy of the face.

**3 Trace the Face**
Place a piece of drawing paper over the face map on top of a lightbox. Trace the map lightly onto the drawing paper. Sketch the face details using the photo as a reference. Don't be worried if it doesn't look exactly like the photo. You're just using it for inspiration.

Photo Credit: Virginia Woolf by George Charles Beresford, July 1902.

Visit CreateMixedMedia.com/Mixed-Media-Portraits for FREE bonus materials.

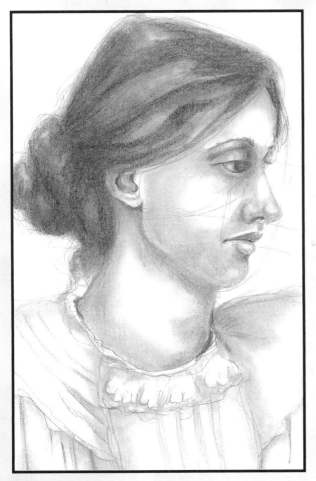

## 4 Add Shading

Shade the drawing using the photo as a guide. Use light crosshatching to establish the shaded areas first, then move to darker pencil leads and a blending stump to further add tonal values to the sketch.

Work the hair by adding sketchy lines to give it shape, then fill in with dark graphite. Use a kneaded eraser to lift the highlights in the hair and to give it movement. Add additional pencil strokes to create wisps of hair and individual strands.

## 5 Make a Mixed-Media Painting

Use a copy of the sketch to create a mixed-media painting. Adhere it to a substrate and paint directly on top of it, or try using one of the techniques from Chapter 5 to create a mixed-media portrait. Here I used acrylic paint techniques from "The Real Hue" (Project 4 in Chapter 5).

**Roses in My Hair**
by Pam Carriker
collage, acrylic, charcoal and gesso on
watercolor paper
10" × 8" (25cm × 20cm)

# CHAPTER 3

# Personality

It's time to make it personal.

Now that you've practiced some of the basics for drawing faces, it's time to give them some of your personality! If a bit of a stylized look is what you're going for—you know, those faces that you saw and you know who drew them before you even saw a name—you too can achieve this by putting a little bit of yourself into your work. Do you have large eyes, a button nose, a long neck, a unibrow, a pouty mouth? Maybe there's a "flaw" in your face that you aren't particularly fond of. (Did you ever wonder if Frida Kahlo liked her unibrow?) Instead of trying to not look at it, flaunt it! Self-portraits don't have to be a replica of your face, but they can have traits from you that make them more personal and unique.

Find something of yourself to put into your work to truly make it your own. I have a bump on my nose from getting hit with a baseball when I was young. I hated it through my teen years and gradually grew to accept it as I got older. (My husband says it's "regal," so I'm not going to argue with that!) I've come to terms with it and love to use that little bump in my work. I feel like it represents my self-image through my life, both the good and the bad.

You may also begin to unintentionally develop faces with a specific look. This is your artistic style emerging. Embrace it! If you draw with a heavy hand, go with it. Maybe your work is edgy with energy that shows up in your drawing technique. No one says you have to draw a certain way. A true artist recognizes her style for what it is and goes with it rather than fights against it.

# BENDING THE RULES

## SOME RULES ARE MADE TO BE BROKEN

You can begin to explore your own style by paying attention to a few things and by tweaking your own face maps. While there are many "rules" to drawing portraits, we are here, because, as mixed-media artists, we know there's even more fun to be had when we play around and bend a few rules! That said, there are some things that can make a face look off kilter. This is why it's important to start with a good foundation for facial feature placement. This will help you when you are trying to identify things that aren't working in your drawings and paintings.

## PULL SOMETHING FROM YOUR OWN FACE

Look through your sketches and see if something consistently jumps out at you. Do you always make your eyes a little too big, or do your faces have small noses or long necks? Paying attention to something you do unconsciously is one way to recognize your natural style as it emerges. Pull something from your own face or head and exaggerate it slightly in your portraits. This can be a bump on your nose, high cheekbones, a wide forehead, a beauty mark, thick eyebrows—anything that you love about your face or maybe something that bothers you. Putting something of you into your portraits instantly sets them apart from someone else's.

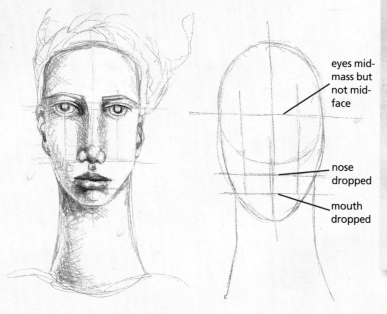

eyes mid-mass but not mid-face

nose dropped

mouth dropped

**Longer Nose**
Creating a longer nose requires placing the eyes mid-head mass but still with one eye width between. The relationship of the nose to the mouth remains the same.

## TWEAKING YOUR FACE MAP

Here are some facial features that can be easily tweaked to help create a more stylized look:

- The shape of the head can be oval, round or square and can be changed once the facial features have been established.
- The eyes should remain in the middle of the head vertically, but you can play with spacing them farther apart.
- The face is about five eye widths wide. If you want to break this rule, you can make the eyes extra large, but keep one eye width between the eyes.
- The nose can be longer or shorter than normal. Change the attitude by moving the nostrils up, down or centered. Try the three-ball method of adjusting the nose shape (see Chapter 2).
- The mouth can vary greatly in shape and size and should fall around halfway between the bottom of the nose and the chin.
- The thickness of the neck is another area that can be grossly exaggerated.
- The hairline can be moved backward or forward to create very different looks.

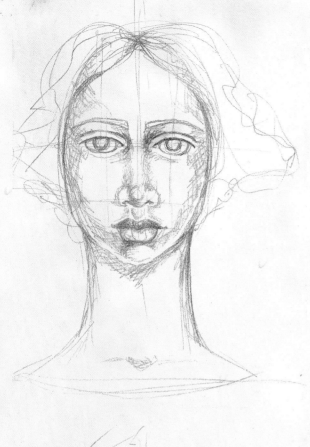

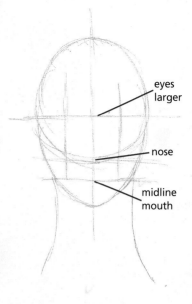

eyes
larger

nose

midline
mouth

## Larger Eyes

While the eyes are larger in this example, they remain in the same position on the face. All other features also remain in the same position.

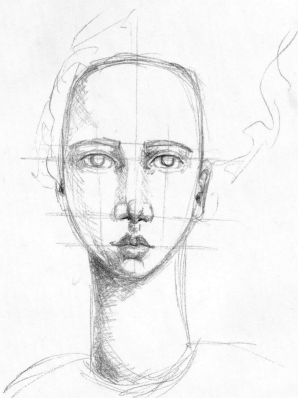

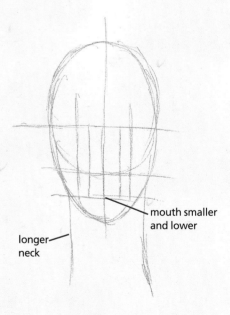

mouth smaller
and lower

longer
neck

## Smaller Mouth

The mouth is both smaller and positioned lower in this example. By elongating the neck as well, the overall look is changed.

# PIECING TOGETHER PORTRAITS

Pulling favorite features from several drawings and tracing them onto a new face is a fun and helpful exercise. As you sketch, you might find that you like the eyes on one drawing, the mouth on another and the nose on a third. Piecing together your favorite parts on one face gives you a new base to work from and helps propel you along the road to developing your own portrait style. Tracing your own work is the perfect way to help your drawing muscles stay toned and tuned into your journey.

To piece together your own portraits, simply select sketches that are roughly the same size. (This is easy if you've been practicing using the same face map for several drawings, or you can change the size on a scanner/printer.) Trace the face outline onto a new piece of paper using a lightbox, then add the face-mapping lines. Next, slide a sketch with eyes that you like under the paper and trace the eyes in the appropriate spot on the map. Like only one of the eyes? Trace it and then flip it over sideways and trace the same eye on the other side so both eyes will match. Next trace the nose and mouth from other sketches, then finish your new face with shading and additional sketching as needed. You now have a new model to work from as you move forward with your drawing.

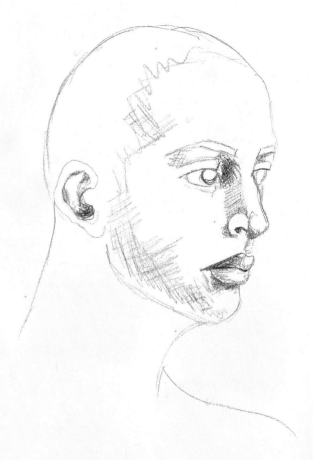

**Perfect Portrait Pieces**
Use favorite features from various sketches to piece together a portrait of perfect parts.

# REUSING YOUR SKETCHES

You will be amazed by how many different ways you can explore one sketch when you scan it. (There are fifteen ways in Chapter 5!) You may be sketching for fun, practice or relaxation, but those sketches can and should be reused in your future work.

When you look at a scan of your work, you will see things you didn't notice as you were working. Maybe one eye is larger than the other or something is lopsided. It's a great way to gain a new view of your work. It also gives you the opportunity to print it in different sizes, and you'll have a readily available supply of images for blog posts and your website.

Reviewing your work on a screen can also help you see when a sketch is finished. It's easy to overwork a drawing, and this allows you to look back and see if and when you went too far. I like to scan sketches while they are in the rough stage for use in future work or to practice drawing from. Even the wonky faces can find new life in your art journal.

## TRANSFER TECHNIQUES

There are several methods for transferring sketches to other substrates for mixed-media work. You don't need expensive tools to transfer sketches—just a pencil will do! Here are a few of my favorite methods:

### Graphite Rubbing

To create a graphite rubbing, simply turn a sketch over onto a substrate (this works best with sturdy paper) and burnish the back of the sketch with a bone folder tool. This will cause ghosting or the transfer of graphite. The image will be in reverse, which is a fun way to play with your work.

### Graphite Transfer

To create a graphite transfer, rub the back of a copy of a sketch with graphite (I like woodless graphite sticks), then place the sketch graphite side down onto a substrate. Use a stylus or ballpoint pen to trace the necessary lines of the face.

### Graphite Paper

Place the transfer paper graphite side down on a substrate with a sketch copy on top. Use a stylus or ballpoint pen to trace the sketch. Transfer paper comes in a variety of colors, so you can choose one that works best for your background.

### Copy/Collage Option

This method allows you to resize your sketch or add multiple sketches to one piece of work. Adhere the sketch copy to a substrate with Mixed Media Adhesive or other collage glue. Mixed Media Adhesive also provides a little tooth to help paint and layers adhere.

### Lightbox or iPad Lightbox App

Even if you don't have a lightbox or iPad, you can go old school and use a window! Lay a sketch right side up with a substrate on top and trace with a pencil or charcoal. You can see through just about anything that hasn't already been painted or collaged.

### Projector/Large-Scale Resize

I use an Artograph Tracer Projector for really big transfer jobs when I want an exact copy of a sketch on a much larger scale. Project the image the size you want it onto a substrate taped to a wall and trace the lines you want.

### Tool Staples

Transfer paper and a lightbox are staples in my studio as are studio wipes for quick cleanup of tools, tables and hands.

# ARTISTS SHARE: STYLE

## DO YOU FEEL THAT YOUR WORK HAS A SIGNATURE STYLE OR LOOK? HOW LONG DID IT TAKE TO ACHIEVE IT?

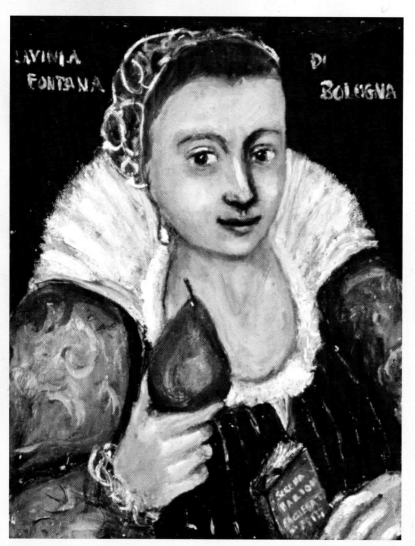

**Lavinia Fontana of Bologna**
by Serena Barton
oil on canvas
20" × 16" (51cm × 41cm)

"I didn't set out to develop a particular style. As an adult I studied my favorite painters of the Renaissance and other periods to see how they achieved light and shadow, facial modeling, etc. My earliest faces showed a lot of life and emotion, which resulted from my long interest in faces and how they show people's inner lives. As my technique improved, I began to miss some of the liveliness in my early pieces that came about from less-than-perfect drawing. To keep my portraits alive, I now allow some asymmetry to remain in the eyes, mouth or other features. Most of my portraits depict women artists of the past, so any clothing, jewelry or hair-styles relate to past eras. I tend to paint loosely and to leave something to the viewer's imagination. I like my portraits to be a little mysterious."

—SERENA BARTON

"Well, the answer you're trained to say is, 'All my life,' and to some degree that is correct. I see threads that trace back to the Moon Monsters I was drawing in preschool. But where I started seeing a consistent stylistic pattern was probably my third year of undergraduate work."

—MICHAEL DEMENG

Visit CreateMixedMedia.com/Mixed-Media-Portraits for FREE bonus materials.

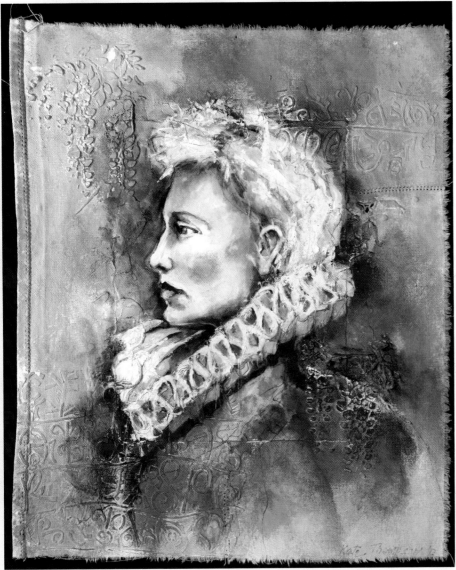

**Queen**
by Kate Thompson
plaster, acrylic and ink on vintage fabric
10" × 8½" (25cm × 22cm)

"Yes, I do. I like to use a lot of pencil lines on top of my work, and I'm told my portraits look like sculptures, that they are molded. I did sculpture before and really focus on the planes of the face."
—KATE THOMPSON

"My signature style incorporates color and even neons within the face to achieve a dimensional feel. It took about a year of painting nearly every day to nail down my style. My faces do keep evolving and changing slightly with shape and texture, and I'm excited to see how they'll change in the future."
—MINDY LACEFIELD

"Yes. I venture all over the place due to my moods, but, when it comes down to it, most people can identify my work."
—JANE SPAKOWSKY

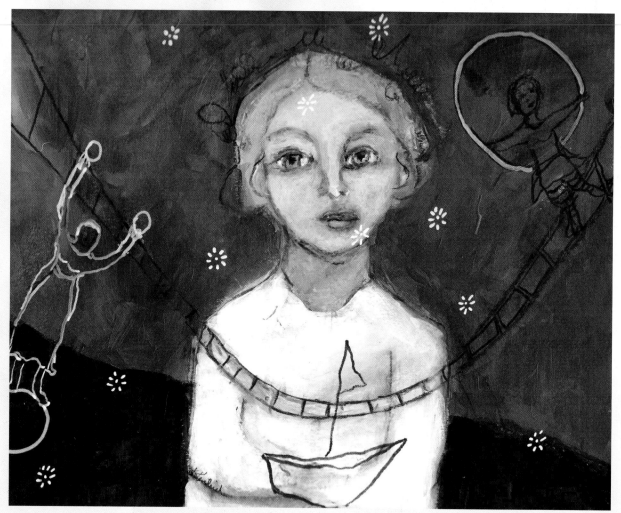

**The Balancing Act**
by Katie Kendrick
acrylic, graphite, charcoal and pastel on
140-lb. (300gsm) watercolor paper
9" × 11" (23cm × 28cm)

"I do seem to have a signature style, at least other people tell me I do and recognize my work. In a lot of ways, I feel like I've always had it. Because I'm self-taught and didn't study art academically, I wasn't exposed to many influences and just played around with simple faces. They slowly got more intricate as I practiced more and had more experience and skills to draw from."

—KATIE KENDRICK

"I do have a signature style, although it changes from time to time. When I started painting faces, I called them 'Pretty Girls' because they were! Now my style is more what I refer to as 'Ugly Girls.' I can find more humor in a not-so-perfect face, and it gives my work a looser feel. I can pinpoint three distinct changes over the seven-year period that I have been painting faces, the third occurring presently."

—SUNNY CARVALHO

Visit CreateMixedMedia.com/Mixed-Media-Portraits for FREE bonus materials.

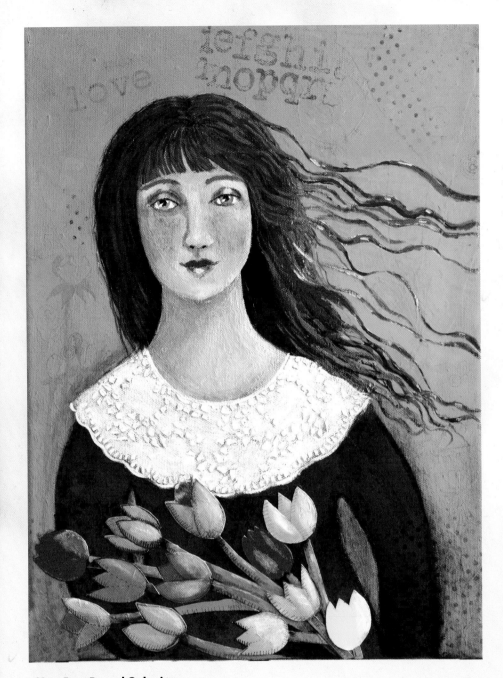

**Your Eyes Reveal Galaxies**
by Cindy Silverstein
acrylic, paper and ink on canvas
16" × 12" (41cm × 30cm)

"It was about four years ago that I started paying closer attention to how I was creating my faces. This was a direct influence from Pam's teaching. I began to challenge myself to draw faces with more depth and expression. This required greater focus, presence and practice. Change and progress came quickly when I adopted this approach. Within a year, I saw a unique style emerging, seemingly spontaneously. I felt more confident putting my work in front of the public, which gave their most enthusiastic feedback to the paintings that included faces."

—CINDY SILVERSTEIN

"Yes, I think I do. I love the power of a line and a mark, so I make my faces very imperfect and scribbly. I found some artists to emulate and kept working until I got better. I feel like I'm still learning and working at it."

—DINA WAKLEY

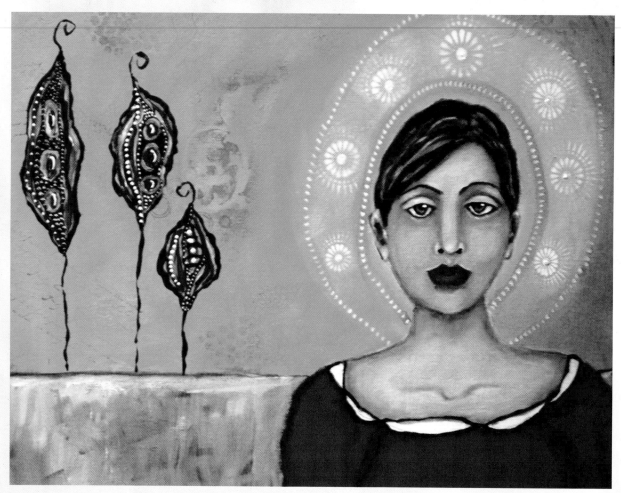

**Cake Walk**
by Cynthia Stroo
acrylic, black ink and Stickles on canvas board
12" × 16" (30cm × 41cm)

"Yes, I feel like my signature style developed after making hundreds of drawings. Time and practice are needed."

—CYNTHIA STROO

"Yes, I definitely have a signature style to my work. It's vibrant and colorful. The faces I draw are raw and not structured or 'perfect.' They are colorful and created with a mix of collage, paint and mark-making. I also create faces using a mix of handwork and digital techniques, using either Photoshop or various iPad apps. My artistic style has developed over the past twenty years since I studied graphic design in college. I started drawing faces in my art journals and in my art more consistently about thirteen years ago. I continue to experiment with new techniques to push my style to evolve."

—TRACI BAUTISTA

Visit CreateMixedMedia.com/Mixed-Media-Portraits for FREE bonus materials.

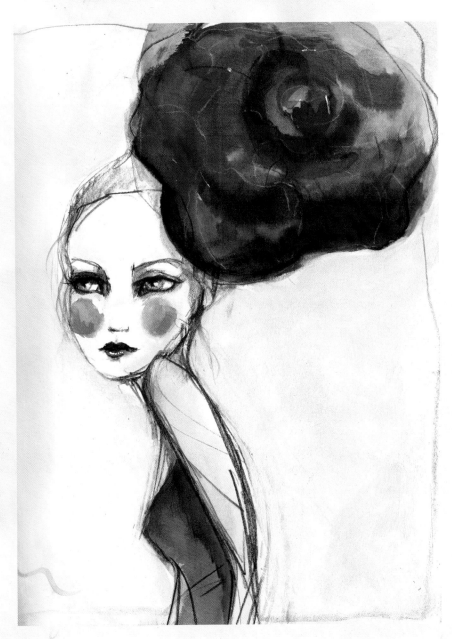

**Blossom**
by Jane Davenport
watercolor and colored pencil on mixed-media paper
12" × 9" (30cm × 23cm)

"I have taught thousands of people to draw, and, even when people think they are copying me exactly, their own style is shining its light. So I think your own style is with you from the start. Learning to see it and trust it takes time and a lot of drawing.

"I also think your style is constantly evolving, which makes being an artist even more exciting because, even though it's your artwork, you are still never 100 percent sure of where you may be going as you create. I can see elements of my current work that span back to childhood drawings."

—JANE DAVENPORT

"Yes. A few years ... but it continues to change, which I love."

—MISTY MAWN

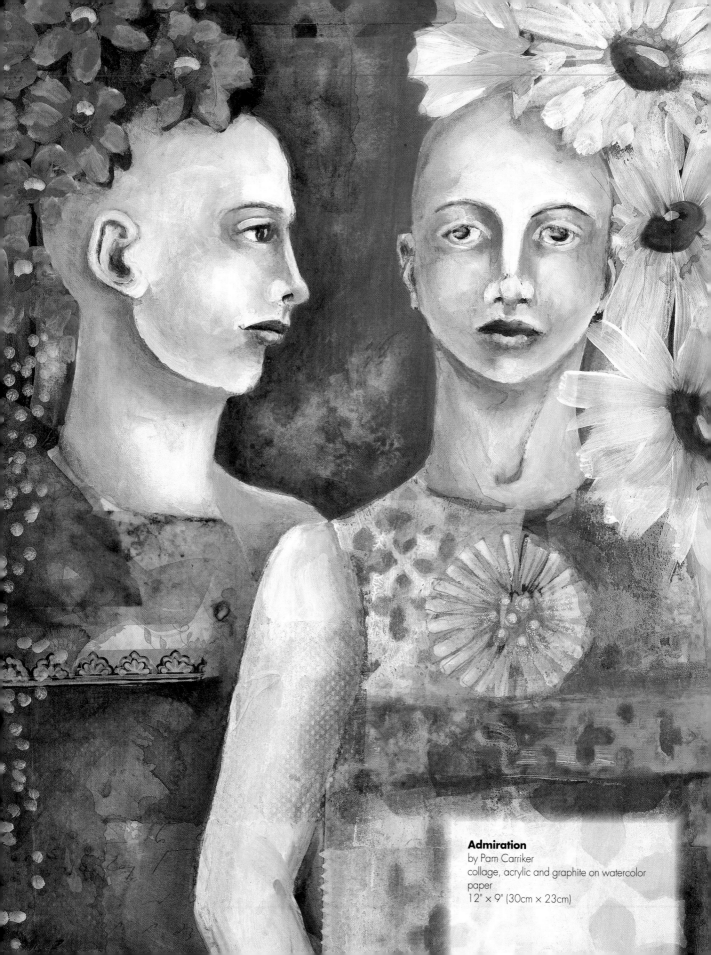

**Admiration**
by Pam Carriker
collage, acrylic and graphite on watercolor paper
12" × 9" (30cm × 23cm)

# CHAPTER 4

# Palette

Color is where the magic happens when creating mixed-media portraits. Playing with color and mediums and discovering what happens as you combine, layer and experiment will propel you forward in your pursuit of portraits. By learning some of the basics of mixing portrait palettes using a variety of mediums, you will gain confidence to continue experimenting and playing on your own.

In this chapter I'll share simple color combinations for mixing skin tones using paint, water-soluble crayon and PanPastels. We'll explore adding mediums to the crayons and pastels to see how they react differently or become more stable. Using color wheels, we'll mix tonal values and neutral colors; explore hue, tint, tone and shade; and make complementary colors play nicely with each other to extend your palette color choices.

The goal here is to stretch out of your skin-tone comfort zone! Experiment, play, try something unexpected. All is fair in the world of mixed-media art, and that applies to portraits, too. You'll see sample color wheels and color slides on the following pages, but, by actually mixing and painting them yourself, you'll gain the confidence that comes only with the hands-on knowledge of doing the work yourself. We'll use the mixtures and mediums later in the projects chapter, so don't skip over this important color play.

I recommend playing with color in a journal and taking notes as you go along. This will serve as a tool for future reference. I love to use the Strathmore Field Watercolor notebook for these studies. It includes plain paper for note taking and a nice, heavy watercolor paper to work the color palettes. It's small enough (just fifteen pages) to use solely as a color workbook.

# MIXING SKIN TONES

When mixing skin tones, you don't have to make it complicated. There are various formulas available, even whole books dedicated to mixing various skin colors, but you can get a nice range with just Yellow Ochre, Raw Umber and Burnt Sienna plus white and black. You probably already have these hues (colors) in your stash or something close to them.

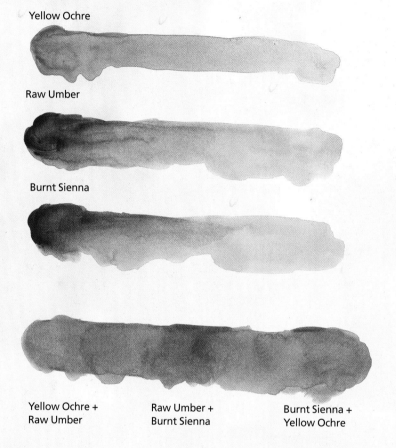

Yellow Ochre

Raw Umber

Burnt Sienna

Yellow Ochre +
Raw Umber

Raw Umber +
Burnt Sienna

Burnt Sienna +
Yellow Ochre

## Color Wash Slides

These color slides show each hue washed out with water to illustrate the range from opaque to sheer. To create your own slides, simply dip a no. 8 round brush in the full-strength paint and put a bit on the paper, then rinse your brush with water and use the wet brush to slide the paint from full strength to washed out.

## Color Mix Slides

These slides show mixes of two colors with varying mix ratios in the middle. This is a great way to see the varying colors each combination can make. I've used only Yellow Ochre, Raw Umber and Burnt Sienna to show the wide range of skin colors you can achieve with this limited palette.

## MATCHING COLORS

If you want to match a color from a different brand of paint than what you have, find the pigment name and number, which is usually located near the paint name. The pigment name will be abbreviated (e.g., Primary Red = PR). If it includes more than one pigment, multiple pigment abbreviations will be listed. By matching the pigment name and number rather than the name of the paint, you can work across brands and find the correct color.

# TONAL VALUES

Continuing to work with Yellow Ochre, Raw Umber and Burnt Sienna, we can mix them with white and black to create a range of tonal values of each color. For each color wheel, first add the pure color to the wheel, then mix it with varying amounts of white, white and black, and black to achieve many tones of that color.

These color wheels show the ranges of the pure colors mixed with white and black. Remember, you open up the possibility of many, many more color values when you mix these pure colors together as we did on the Mixing Skin Tones page.

You can draw these color wheels freehand or use the template at the end of the book. You can also download and print the template at CreateMixedMedia.com/Mixed-Media-Portraits.

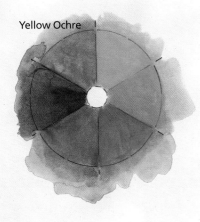

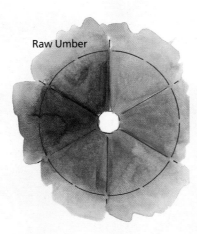

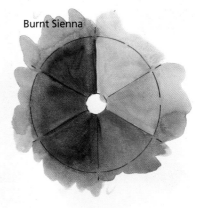

**Tonal Color Wheel With Yellow Ochre**

**Tonal Color Wheel With Raw Umber**

**Tonal Color Wheel With Burnt Sienna**

## TONAL VALUE TERMS

Hue = color
Tint = hue + white
Tone = hue + white + black
Shade = hue + black

# HUE, TINT, TONE AND SHADE

## USING NONTRADITIONAL COLORS

Experimenting with a hues, tint, tone and shade can open your eyes to new possibilities when choosing a portrait palette. I love to test paints in this way, paying special attention to the tint, tone and shade as they totally change the appearance of the hue. It helps me to be courageous and choose colors I'd never normally choose for creating a portrait. Any paints can be used for this, so I encourage you to pull out twelve colors that are representative of those on a color wheel and see how they play out.

Note: It's always a good idea to write down the paint brands and colors chosen for this exercise so you have a reference later on.

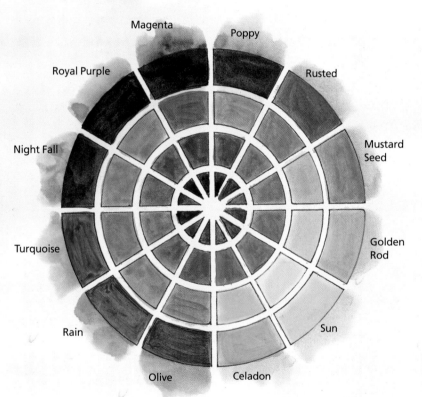

Magenta
Poppy
Royal Purple
Rusted
Night Fall
Mustard Seed
Turquoise
Golden Rod
Rain
Sun
Olive
Celadon

### Make Your Color Wheel

Use any brand or colors you like for this exercise. I used Derivan Matisse Fluid Matte Sheer Acrylics.

1. Draw a color wheel using a pencil or permanent black pen.
2. Paint the hue (pure color) in the outside color block.
3. Mix the hue with white to get the tint, and paint that in the next inward box.
4. Mix the hue with white and black to get the tone, and paint in the third inward box.
5. Mix the hue with black to get the shade, and paint in the last inward box.

Note: Change your water frequently and rinse your brush between each mixture to get the purest color swatches.

# GOING GRAY NATURALLY

Neutral or grayed colors make excellent choices for painting interesting faces. To create gorgeous grayed colors, you don't actually mix the colors with gray paint (that's how you get the tints we created on the Tonal Values page). These grays are even more yummy, and you can create your own, which will vary depending on what hues you use. It's a really fun way to experiment even further with color and to extend what you can do with the paints you already have. I used Derivan Matisse Fluid Matte Sheer Acrylics.

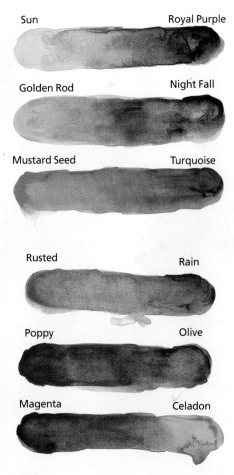

**No-Mud Neutrals**
Create colorful neutrals by mixing the three primary colors (red, yellow and blue) together, and then combine that grayish color with each of the colors on the color wheel. This makes a gorgeous set of neutral colors.

**Grayed Colors**
To create a grayed color, mix two complementary colors (colors opposite each other on the color wheel). To make complementary color slides, place a dab of two complementary colors in a line with space in between, then mix the two to form a range of colors. This is a fun way to experiment, and it might make you want to try new colors in your portraits.

# MINI-DEMONSTRATION
# NEUTRAL COLOR MIXING

It's easy and fun to create a portrait color palette using Caran d'Ache Neocolor II water-soluble crayons. This easy-to-use medium can be applied over acrylic paints, giving it great versatility for the mixed-media artist. Using just three primary colors plus white will give you a great portrait palette.

## MATERIALS

Caran·d'Ache Neocolor II: Carmine, Ochre, Prussian Blue

no. 8 round

watercolor paper

pencil

Mixed Media Adhesive or other gel medium

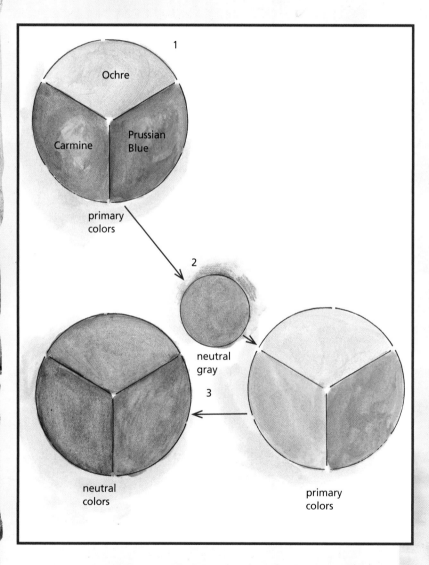

1
Ochre

Prussian Blue

Carmine

primary colors

2
neutral gray

3

neutral colors

primary colors

**1** Draw a simple color wheel to try out the colors in their original state. Color directly onto the color wheel and activate with a wet brush.

**2** Draw a small circle on your sample page. Color equal amounts of the primary-colored Neocolor II crayons onto a palette. Use a wet brush dipped into Mixed Media Adhesive or other gel medium and mix to form a gray color. Paint this in the small circle on your sample page.

**3** Mix an equal amount of the gray color mix with a primary color to form the neutral of that color, and paint it on a new color wheel. Do this for each of the three primary colors.

## SETTING WATER-SOLUBLE CRAYON

When you add Mixed Media Adhesive or another gel medium to water-soluble crayon, it sets the crayon, making it permanent and allowing you to paint over the top of it when it's dry.

# WET- AND DRY-MIXING COLOR WHEELS

PanPastels are soft pastel colors packed in a unique pan format. The special qualities of PanPastels mean that artists can blend and apply dry color like fluid paint. PanPastels are loaded with the finest-quality artist's pigments for the most concentrated colors possible. The colors have excellent lightfastness and are fully erasable. They can be mixed together wet or dry for a complete painting palette.

## MATERIALS

Mixed Media Adhesive or other gel medium

no. 8 round

PanPastels: Burnt Sienna, Raw Umber, Yellow Ochre

watercolor paper

permanent pen or pencil

Sofft knife

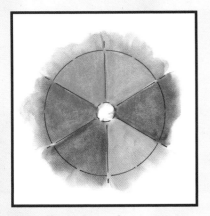

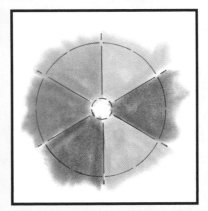

## 1 Sofft Tools and Dry-Mixing

Draw a color wheel with a permanent pen or pencil. (You can also trace the template at the end of the book.) Paint a layer of Mixed Media Adhesive over the color wheel with a no. 8 round and let dry. This will give the paper tooth so the PanPastels can grab onto it.

Use a Sofft knife applicator to lift the PanPastels by gently patting the Yellow Ochre pan with the knife several times. Then simply pat onto the color wheel, adding each of the three pure colors first, leaving an empty space between them. Then mix the colors together directly onto the color wheel by patting one color over the next one.

## 2 Medium and Wet-Mixing

Draw a second color wheel with a permanent pen or pencil. Fill in the color wheel the same way. When finished, use a damp no. 8 round dipped into Mixed Media Adhesive and blend together. This will fix the PanPastels and create a paintlike consistency.

## SOFFT TOOLS

Sofft Tools, though developed for using with PanPastels, can also be used with other mediums such as watercolor, acrylic and charcoal. They are reusable and can be wiped off or rinsed out to be used over and over. One nice thing about them is that they don't leave brushstrokes.

- **Sofft knives** used with Sofft covers function like a cross between a brush and a knife. Sofft knives can also be used alone as traditional painting knives.
- **Sofft covers** are sized specifically for use with Sofft knives and shapers.
- **Sofft art sponges** are made with semi-absorbent micropore sponge material. Each sponge has a unique shape and size for a variety of applications.

# ARTISTS SHARE: CREATING FACES
## HOW LONG HAVE YOU BEEN CREATING FACES IN YOUR ARTWORK?

**Balinese Girlie Glam Dancer**
by Traci Bautista
acrylic on mixed-media paper
14" × 11" (36cm × 28cm)

"I've been creating faces in my art since I was in high school. I paint both realistic and whimsical 'girlie-glam' faces."
—TRACI BAUTISTA

"I was the 'kid who could draw' at school, and my first job was as a fashion illustrator, so I have been drawing faces both for fun and professionally all my life. I am often asked if I draw anything other than girls' faces. I can flip to unicorns, birds and a bear or two, but I love drawing female faces. (My personal theory is all my girls are, in fact, mermaids.)"
—JANE DAVENPORT

"Ever since I was a wee lad making scary monsters out of crayons and finger paint. That said, I didn't start messing around with the style I currently work with until just after I graduated from college … collage? … I collaged after I went to college."
—MICHAEL DEMENG

Visit CreateMixedMedia.com/Mixed-Media-Portraits for FREE bonus materials.

**Sketched Face**
by Dina Wakley
acrylic, pen and water-soluble crayon on
journal paper
9" × 11½" (23cm × 29cm)

"I always said I couldn't draw.
One year I thought, 'Why
can't I?' So I set about to teach
myself. I've been drawing
faces for about two years."
—DINA WAKLEY

"Pretty much forever, ever
since I was a child of about
nine years old, beginning with
Twiggy. I love creating faces
best of all. It's the subject I
return to again and again."
—VIOLETTE CLARK

**Journal Page**
by Violette Clark
Micron pen, Copic markers, pencil, crayon,
acrylic and spray ink on cardstock
11" × 8½" (28cm × 22cm)

**Eyes Like the Sea**
by Misty Mawn
oil on primed wood panel
12" × 9" (30cm × 23cm)

"I have been painting, drawing and sculpting faces since I was a young child, working with whatever medium was available to me. I have always wanted to be an artist, and portraying faces was what I was first and still am drawn to. Looking back at some of my earlier work amuses and compels me to keep pushing forward to become a better artist. The progress from good, hard work continues to stay true, and I am grateful for that."

—MISTY MAWN

"I drew a lot as a child, and my favorite thing to paint was faces. When I took up art again after many years, I painted a lot of faces, many of them of women artists of the past. As an adult, I've been doing portraits, among other subjects, for about twenty years. I started out painting faces and still lifes on muslin fabric, using fabric paints. This evolved into acrylic on canvas and then to oil on canvas or board."

—SERENA BARTON

"About twelve years ago, I began including faces more regularly in my mixed-media artwork. I was making art that focused on positive affirmations that uplift and encourage people to think loving and positive thoughts about themselves and their lives. I'd been painting landscapes and flowers and wanted to include the human figure with emphasis on the face. The human face has always fascinated me, and I often find myself focusing with wonder on the features and expressions of the people I meet."

—CINDY SILVERSTEIN

Visit CreateMixedMedia.com/Mixed-Media-Portraits for FREE bonus materials.

"I started painting eleven years ago, and within that first year I started painting faces. Of course, they've changed a lot over the years and continue to evolve and change as long as I'm growing as an artist. When I look back, I still see the relationship between my earlier, more primitive faces and those of today."
—KATIE KENDRICK

"As long as I've been making art—my whole life—but primarily over the last eight years or so."
—JANE SPAKOWSKY

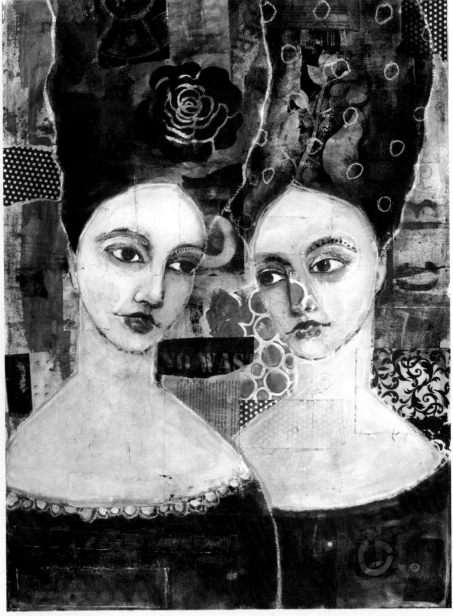

**Talking to Myself**
by Jane Spakowsky
mixed media on 300-lb. (640gsm) watercolor
paper
30½" × 23" (77cm × 58cm)

"My fascination with faces began in high school art classes. I could spend endless hours drawing features over and over again, especially eyes. I've been creating faces in my work for as long as I have been working as an artist. Typically the face is the starting point for me, with the rest of the elements falling into place to enhance the portrait and tell the story."
—ANDREA MATUS DEMENG

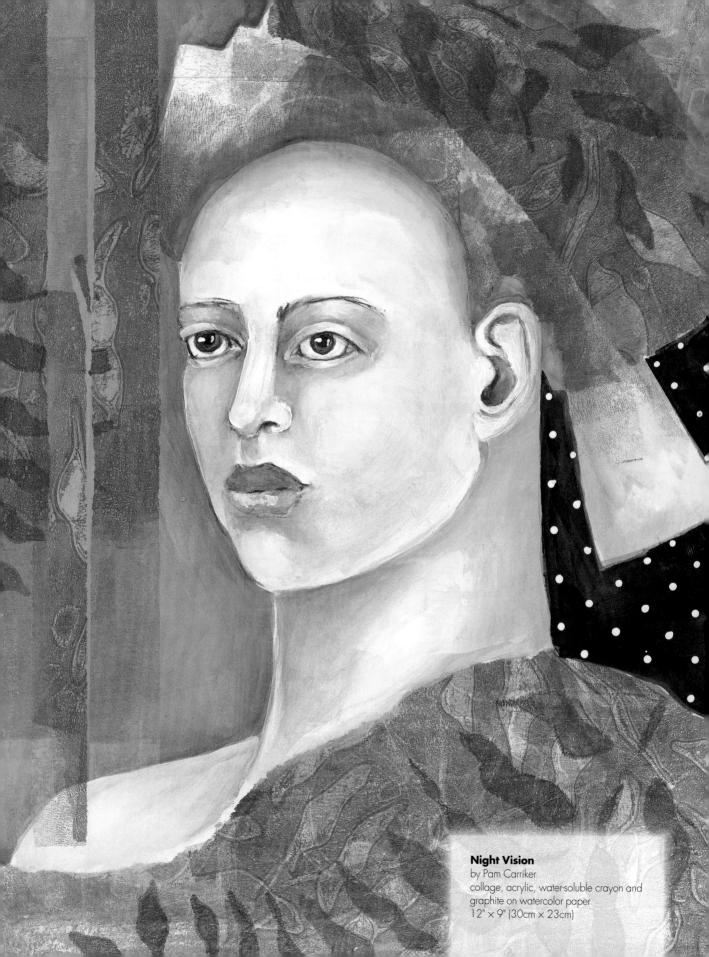

**Night Vision**
by Pam Carriker
collage, acrylic, water-soluble crayon and
graphite on watercolor paper
12" × 9" (30cm × 23cm)

# Projects

In this last half of the book, I'm going to share with you fifteen mixed-media projects using a variety of mediums and techniques. This is where you can begin to build off of the sketches you made in the earlier chapters and turn them into works of art. Sketching is good for more than strengthening your art muscles; it's also a great foundation from which to begin other work.

These projects were designed to share specific techniques and mediums that can be used alone or combined with other techniques and mediums to broaden the creative process. Substitutions for supplies are not only acceptable but encouraged! Don't feel you need to go out and buy exactly what I used. Instead, look at what you have and see if you can substitute. Substituting and experimenting is how your art evolves into your own body of work.

While still bringing new mediums and techniques into the projects, I've tried to use each of the mediums and the substrates more than one time. This makes buying a large sheet of paper more cost-effective as you can tear or cut it to whatever size you want to work on, and it allows you to experiment with a medium in a variety of ways.

## ARTISTS SHARE: MEDIUMS

Here are the contributing artists' favorite mediums. You'll learn how to use most of them in this chapter's projects.

**Violette Clark:** Pen (Micron), pencil, crayons, acrylic paint, collage

**Andrea Matus deMeng:** Acrylic paint, collage, graphite, inks, oil pastels

**Cynthia Stroo:** Acrylic paint, graphite, ink, collage

**Kate Thompson:** Acrylic paint

**Katie Kendrick:** Acrylic paint and collage

**Sunny Carvalho:** Acrylic paint, ceramic, fabric

**Serena Barton:** Oil, cold wax, encaustic, mixed media

**Dina Wakley:** Acrylic paint, crayon, Stabilo All pencil, beeswax, plaster

**Jane Davenport:** Watercolor, acrylic paint, ink, colored pencil

**Cindy Silverstein:** Acrylic paint, ink, pencil, collage

**Michael deMeng:** Assemblage, collage, paint

**Traci Bautista:** Mixed media, acrylic paint, watercolor, collage, marker/pen

**Misty Mawn:** Acrylic paint

**Mindy Lacefield:** Acrylic paint

**Jane Spakowsky:** Paper, acrylic paint

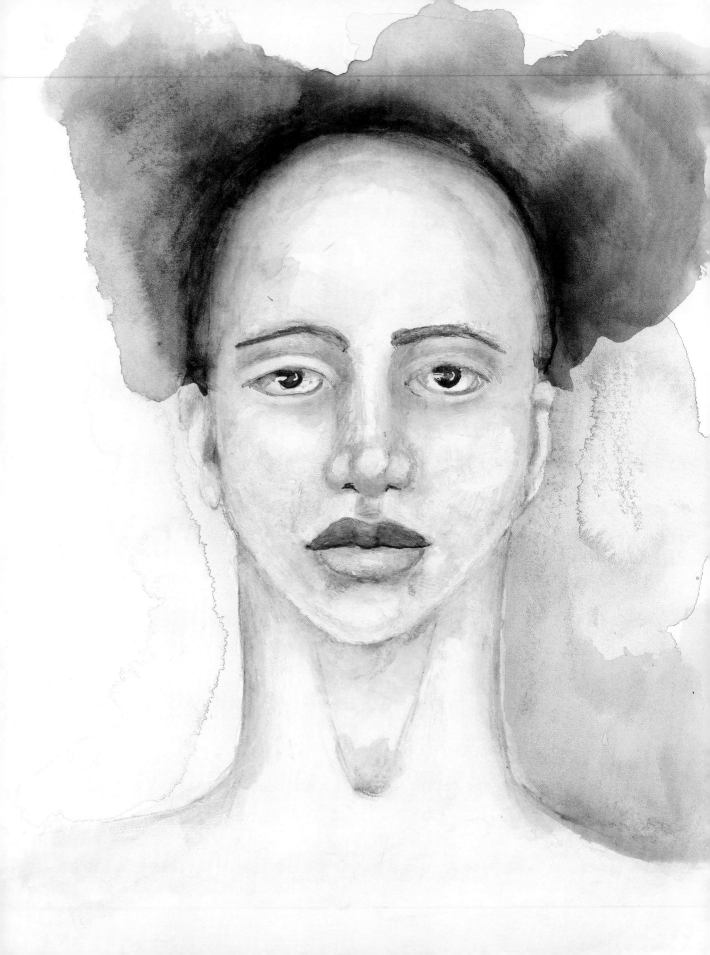

# PAINTING WITH CRAYONS

Caran d'Ache Neocolor II crayons are a huge step up from those crayons of your youth. In this project you can recapture some of your earliest artistic moments using these grown-up crayons to color a portrait mixed-media style.

## MATERIALS

**Surface**
10" × 8" (25cm × 20cm) 140-lb. (300gsm) cold-pressed watercolor paper

**Caran d'Ache Neocolor II Crayons**
Alizarin Crimson, Ochre, Prussian Blue, White

**Brush**
no. 8 round

**Other Supplies**
2H pencil, heat tool (optional), lightbox, Mixed Media Adhesive (or other gel medium), Stabilo All black pencil, wax paper palette (optional)

### 1 Trace a Sketch
Use a lightbox to trace a sketch (or draw one) onto 140-lb. (300gsm) cold-pressed watercolor paper using a 2H pencil, which will make light lines. Trace the basic outlines; you don't need to add any shading.

### 2 Shade the Face
Shade the face with a Prussian Blue crayon. Apply it dry to all shaded areas. Use light strokes. It's like coloring in a coloring book.

## ART ON THE GO

Water-soluble crayons and Mixed Media Adhesive or gel medium are great supplies to travel with. You can mix a small amount of Mixed Media Adhesive with water in a waterbrush with a cap, making sure to rinse the brush and cap it between uses. Take these tools along with you when you're on the go, even on a plane.

## 3 Activate the Shaded Areas

Dip a damp no. 8 round brush into Mixed Media Adhesive (any gel medium will work, though some will create a shiny finish). Then activate the crayon. Blend the crayon with the gel medium directly on the page, using small light strokes. Once dry, the gel medium sets the crayon so you can work over it without reactivating it. Let dry or use a heat tool to speed up the drying process.

## 4 Cover the Face With White

Dip the White crayon into water, then apply in small strokes, covering the entire face. Dipping the crayon in water allows you to apply and spread the color more easily. Apply gel medium to blend, soften and set the crayon. The blue is already set, so it won't mix with the white. Don't let the newly applied white dry. Move on to the next step.

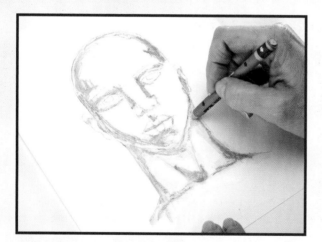

## 5 Add Ochre to the Midtones

Start applying Ochre to the midtone areas of the wet painting. If it isn't wet enough, dip the crayon in water to release more color. Apply more gel medium, and mix the White and Ochre together. Let air dry or use a heat tool to speed up drying.

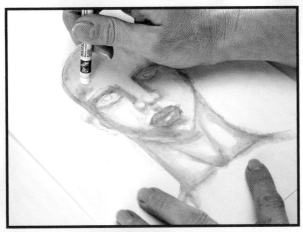

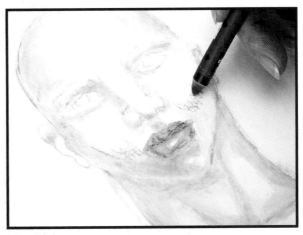

## 6 Go Over the Face With White Again

Dip the White crayon into the water and then go over the entire face again, using light, small strokes. Wetting the crayon allows you to apply creamy color more quickly. Apply gel medium to blend and set the color. If your work gets too wet, dry off your paintbrush and use straight gel medium to blend. Let air dry or use a heat tool.

## 7 Paint the Cheeks, Lips and Background

Apply very small hints of Alizarin Crimson to the cheeks and lips. Apply this color dry, activating the color with a little gel medium. If you use too much, you can dry the brush and blot the color from the painting.

Dip Ochre into water and start coloring the background. Apply more color more heavily to one side. Apply gel medium, using a lot of water to spread and puddle the color. Tilt the page and let the water run. Be sure to tilt away from the face!

## 8 Define the Facial Features and Paint the Hair

Define the eyes, nose and mouth with a Stabilo All water-soluble black pencil. Draw lightly, defining the eyes, pupils, eyebrows, nostrils and mouth. This touch of black helps define the facial features. Apply gel medium with a damp no. 8 round to activate the pencil. Follow the lines of the pencil with your brush. Blend the eyes somewhat, but avoid blending the other features. If it starts to get too dark, rinse your brush and blot to lighten.

Add a heavy colored layer of the Stabilo pencil around the hairline, using scribbling strokes and making it lighter as it goes away from the face. Use a lot of water (no gel medium) to activate the hairline and let it flow. To add color to the hair, dip the crayon of your choice (I used Prussian Blue) and add color to blend with the black. Use a really wet no. 8 round to blend the two together. Let dry. You can use gel medium to set if you'd like, but the pencil will absorb into the paper pretty well, and you will get a more free-flowing effect using just water.

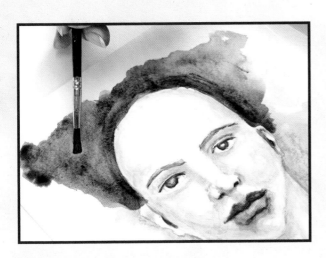

## PAINT FROM A PALETTE

You can also color the crayon onto a wax paper palette, activate with gel medium there and then use it like paint. This is helpful when fine-tuning the painting at the end.

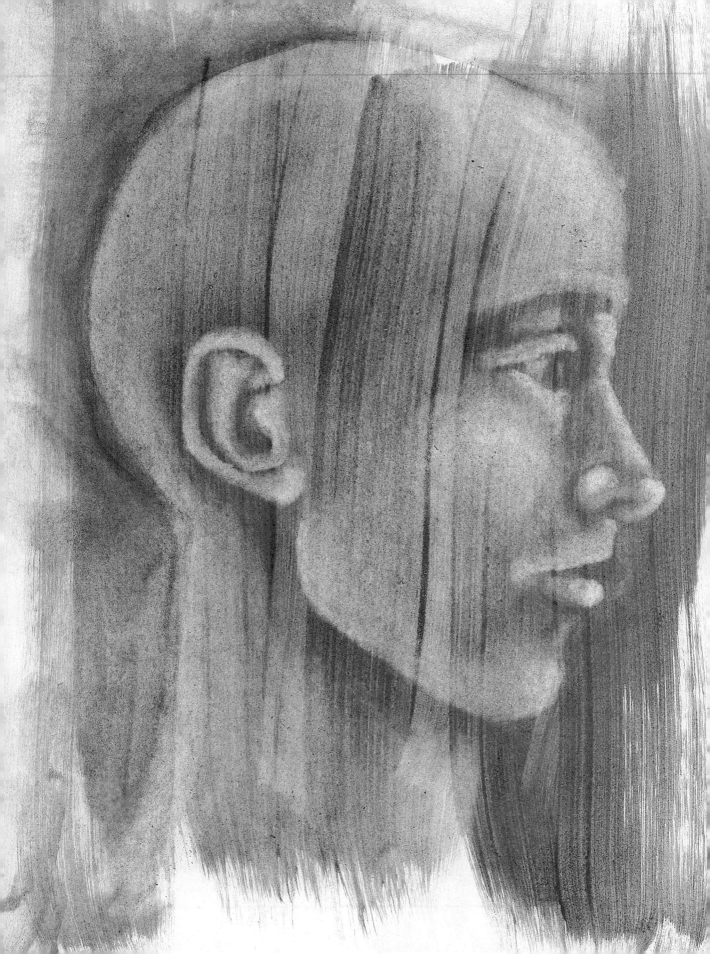

# SKETCHING WITHOUT PENCILS

Reductive drawing helps you turn your focus from thinking about the line to thinking about value, tone and shape. Begin with a background covered in Liquid Pencil Sketching Ink (you can also use a woodless graphite pencil to rub graphite onto the paper). Then use vinyl and kneaded erasers for drawing tools as you lighten the value to create the imagery. By varying the pressure and the type of eraser as you lift the dry Liquid Pencil, you can achieve a wonderful range of tonal values. At the end you can also use a wet brush to further play with this fun medium.

## MATERIALS

### Surface
10" × 8" (25cm × 20cm) 90- or 140-lb. (190 or 300gsm) hot-pressed watercolor paper

### Brushes
1-inch (25mm) flat

no. 8 round

### Other Supplies
black pen, blending stump, electric eraser (optional), kneaded eraser, lightbox, rewettable Liquid Pencil Sketching Ink or a woodless graphite pencil, sharpened pencil-type eraser, vinyl eraser

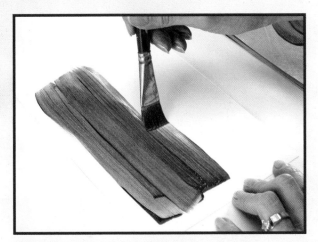

## **1** Cover the Paper With Liquid Pencil
Apply Liquid Pencil to hot-pressed watercolor paper. (Hot-pressed paper has more sizing, which prevents the pencil from soaking into the paper, so you'll be able to remove the color more easily.) Apply the liquid directly to the paper, then blend with a 1-inch (25mm) flat brush, making strokes from top to bottom only. Avoid overworking the color. Let air dry. Note: you can also use a woodless graphite pencil to rub graphite onto the paper.

### HELPFUL TOOLS

Liquid Pencil Sketching Ink, a blending stump and a variety of erasers are necessary tools for this project.

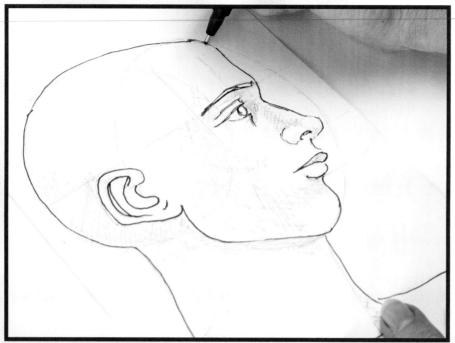

## 2 Darken the Sketch Outlines

Take the sketch you want to work from (or a copy) and go over the outlines with a black pen. I use artist's pens since they don't soak through the paper.

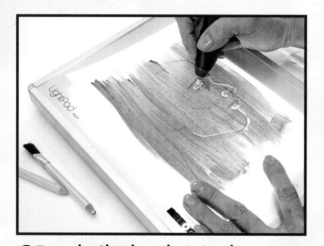
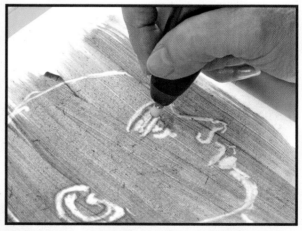

## 3 Trace the Sketch on the Painted Paper

Lay the traced sketch on a lightbox and place the painted paper on top. Use an electric eraser or a pencil-type eraser that you can sharpen to establish the outline of the portrait, going along the inside of the darker lines. Erase the raised parts of the ear to establish its folds. Now establish the lower lip, erasing most of the graphite. Erase the white part of the eye. Erase any other high-lights completely.

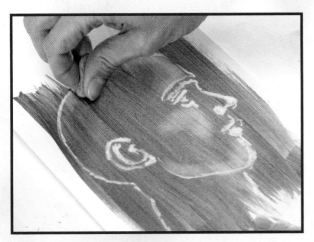

## 4 Blend and Model the Face

At this point you can remove the paper from the lightbox. Establish and refine the highlights. Work back and forth between a kneaded eraser, a vinyl eraser and the sharpened erasers. Start blending in the hard outline of the top of the head. Blend the cheek areas, the back of the head and the jawline. Develop the tones. Don't eliminate the dark dark areas; just lift and blend with the eraser as needed. Use a blending stump to soften and blend the details.

Use a vinyl eraser to redefine the details that you started with the electric eraser, smoothing them out. Vary the pressure to lift more as needed. Touch up all the hard lines, blending them into the face. As your work progresses, it will begin to feel like you're painting with an eraser instead of a brush.

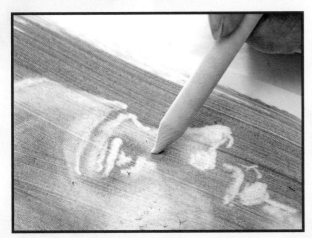

## 5 Soften the Details and Blend the Shadows

Use a blending stump to soften the details. You may need to use an electric eraser to redefine highlights and bring the white of the paper back. Use a blending stump to start blending the shadows, making sure there are no hard lines.

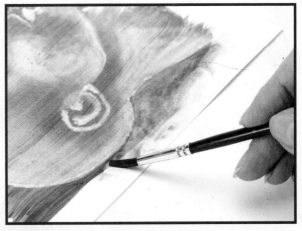

## 6 Reactivate the Background

After you've blended, use a wet no. 8 round to reactivate the background around the head, letting the graphite puddle out. This will eliminate the outside lines and set the background off from the face.

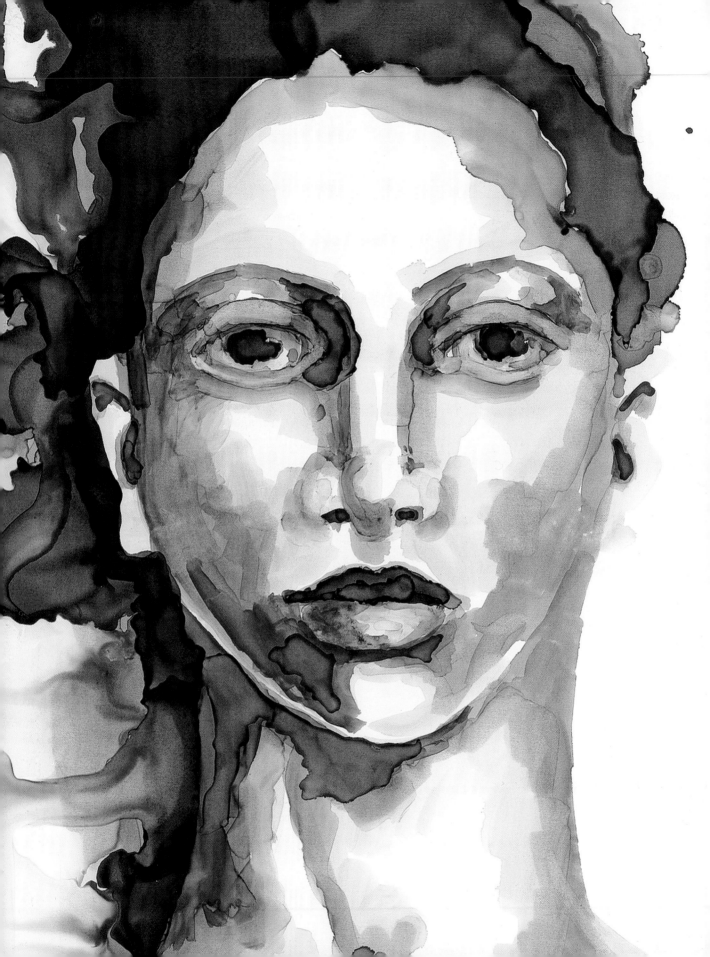

PROJECT 3
# YIPPEE FOR YUPO

I have to admit I was reluctant to try Yupo paper initially. As a former scrapbooker, the thought of creating something that was not archival was a bit outside my comfort zone. But by using alcohol inks rather than watercolor, you get all the fun play and create a piece of work that is more stable and won't just wash off. By using just one color of ink, you can also see the array of colors within the ink as the alcohol blending solution pulls it apart on the paper.

## MATERIALS

**Surface**
white Yupo paper, 7" × 5" (18cm × 13cm)

**Alcohol Ink**
sepia (or color of your choice)

**Brush**
no. 6 round

**Other Supplies**
alcohol blending solution or rubbing alcohol, dish soap, Fantastix tools (2), lightbox (optional), painter's tape, paper towels, rubber gloves, small plastic palette with wells

## ABOUT YUPO

Yupo is 100 percent recyclable synthetic paper with a nonabsorbent, ultrasmooth surface that allows paints such as watercolors and acrylics to sit on top of the paper. The nonabsorbent nature of Yupo also means it will not buckle, no matter how much water you put on it, and it makes colors more vibrant and brilliant than on standard papers because all of the color sits on the surface.

## 1 Wash the Yupo and Set Up the Lightbox
Dirt and oil from your hands may hinder the performance of the Yupo paper, so wash it with mild dish soap and water before using it. Let dry.

Place a sheet of Yupo over one of your sketches on a lightbox, and tape it down with painter's tape. You may be able to see through the Yupo enough that you don't need a lightbox.

## 2 Trace the Face and Establish the Midtones

Use gloves for this step. Squeeze a few drops of sepia (or a color of your choice) alcohol ink into a well on your palette. Then, using a Fantastix tool, pick up some of the ink. The Fantastix will absorb the ink, allowing you to paint with it continuously. Establish the midtones of the face around the outer edge of the face, around the eye area, under the nose and underneath the lower lip.

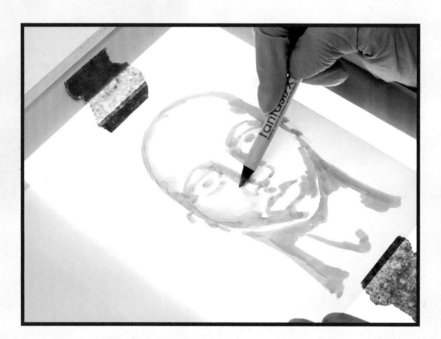

## 3 Blend the Lighter Skin Tones

Put a few drops of the alcohol blending solution or rubbing alcohol onto your palette in a separate well, and dip a clean Fantastix into it. Then use the tool to blend out lighter skin tones from the midtones established in Step 2. The alcohol breaks down the color, separating different hues.

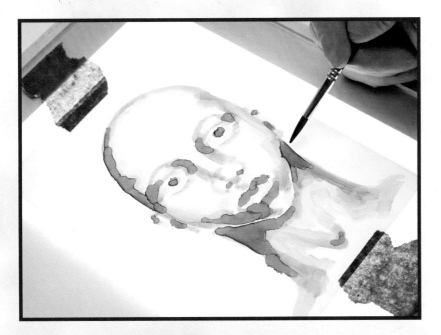

## 4 Establish the Shading

Pick up more alcohol ink on a no. 6 round and begin to drop in the darker areas on the face, including shading on the outer edge of the face, the pupils of the eyes, the inside corners of the eyes, the upper lip, underneath the lower lip, underneath the chin on the neck and any other dark dark areas. The ink will bloom on the paper a bit, so use small amounts and let it organically fill in the shadowed areas of the face. It's not completely controllable, but that is part of the fun of this project.

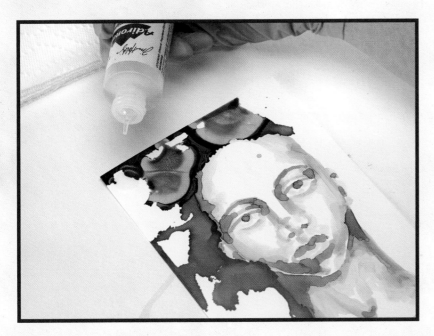

## 5 Add the Hair

Remove the painting from the light-box and start to create the hair. Use the tip of the ink bottle to apply a bead of ink to the hairline on one side of the head while standing the paper over a stack of paper towels. Make sure the ink is dripping away from the face. Let the ink drip and move organically, making magic on the Yupo paper. Shift and let it drip out from the top of the head too. Add some drops of rubbing alcohol or the blending solution to the hair, and let it interrupt the ink to create light and dark areas. Continue manipulating the ink with the Fantastix tool or a no. 6 round as needed.

## READY, SET, ACTION!

It's exciting to see alcohol inks in action on Yupo. To see this for yourself, you can view a video of this project and learn more about the uncontrolled nature of this medium and how to fix mistakes if things get a little too wild! To watch the video, go to CreateMixedMedia.com/Mixed-Media-Portraits.

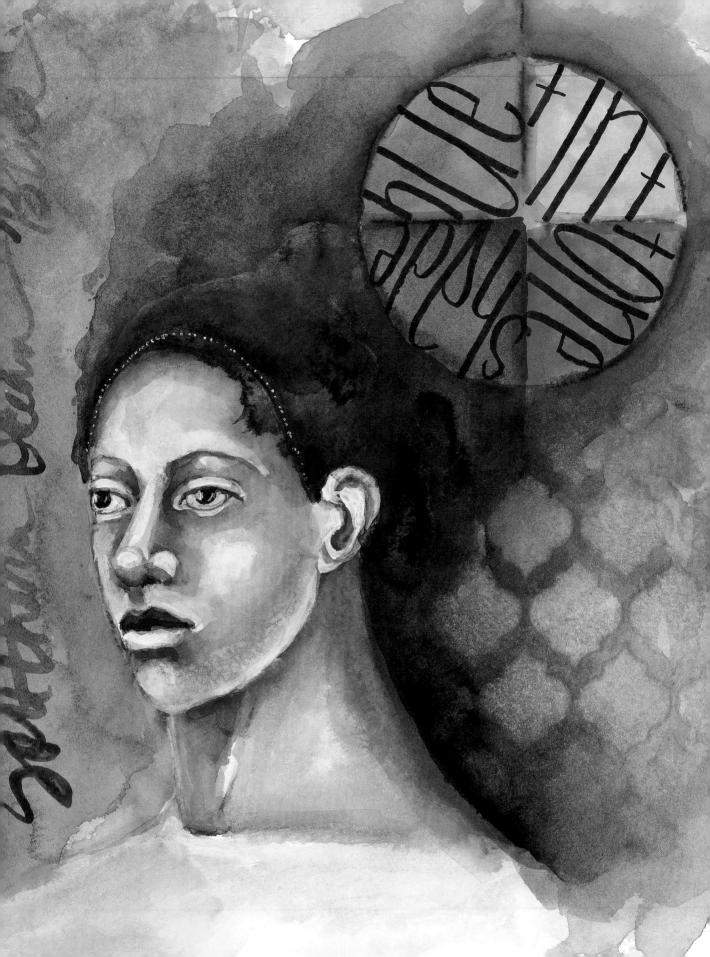

PROJECT 4
# THE REAL HUE

Painting portraits outside the normal color palette can be surprisingly fun. By using the color wheel you created in the "Hue, Tint, Tone and Shade" exercise in Chapter 4, you can get a peek at the way a single color can play out when mixed with white, gray and black. Your color choice might be outside your comfort zone, but when you look at its tonal qualities, you can begin to see the possibilities for creating one-color portraits.

## MATERIALS

**Surface**
10" × 8" (25cm × 20cm) 140- or 300-lb. (300 or 640gsm) cold-pressed watercolor paper

**Acrylic Paint**
black, white, gray (or mix white and black together) and a color of your choice

**Brush**
no. 8 round

**Other Supplies**
baby wipes, lightbox (optional), palette, Stabilo All aquarellable black pencil, stencil

## 1 Trace a Face Sketch and Color Wheel
Trace a face sketch using a Stabilo or other water-soluble black pencil on watercolor paper, using a lightbox or other light source. Add a color wheel to the paper on the upper right corner (use a stencil, draw it freehand or trace the template at the end of the book).

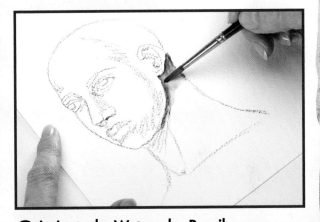

## 2 Activate the Watercolor Pencil
Remove the paper from the lightbox. Activate the pencil with a wet no. 8 round brush. Allow the pencil to bleed out in a watercolor effect into the shaded areas, both around the face and in the background to the right of the head. The cold-pressed watercolor paper will absorb a lot of liquid, so be generous with the water. Soften the edges of the color wheel with the wet brush as well.

### GRAY MATTER

A neutral, midtone gray palette is ideal for mixing accurate color values. Paint will show true on a gray background. I love Jack Richeson Grey Matters disposable paper palettes for the ease of use, easy cleanup and especially the lovely neutral gray background.

## 3 Paint the Color Wheel

Refer to your color wheel from the "Hue, Tint, Tone and Shade" exercise in Chapter 4 to determine the hue you want to use. (I'm using Matisse's Southern Ocean Blue.)

Put a small amount of each of the paints onto a palette. You will be mixing the tint, tone and shade of your chosen color as you work your way around the simple color wheel. Start by painting the straight hue in the upper left section of the color wheel, right over the wet pencil. The paint will bleed out from the wheel. Mix the tint (white + the hue), then paint this mixture in the upper right section of the wheel. Mix the tone (gray + the hue), and paint this mixture in the lower right section of the wheel. Mix the shade (black + the hue), and paint this mixture in the remaining color wheel section.

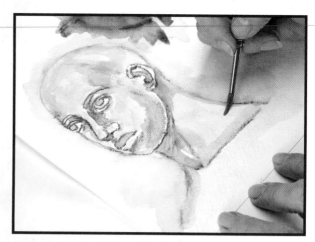

## 4 Establish the Highlights

Use the tint mixture to establish highlight areas first, including the cheekbones, forehead, nose and lower lip. Use a very wet no. 8 round throughout the painting process to help with blending.

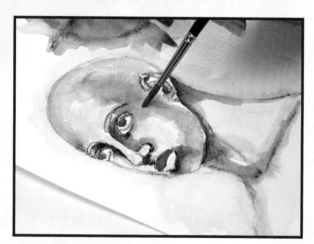

## 5 Establish the Shadows

Use the shade mixture to establish the shadowed areas, including the inside corners of the eyes, the inner ear, the upper lip, under the lower lip, under the nose and under the chin. Continue using a very wet no. 8 round.

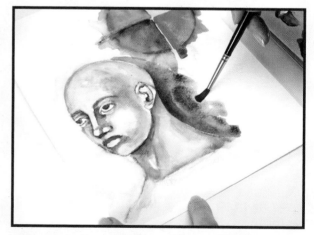

## 6 Create the Midtone Areas

Continuing with a very wet brush, use the tone mixture to create the midtone areas. These areas between the highlights and darks are along the jawline, at the side of the nose, under the eyes, around the nostrils, under the chin, behind the ear and around the outside edge of the head.

Visit CreateMixedMedia.com/Mixed-Media-Portraits for FREE bonus materials.

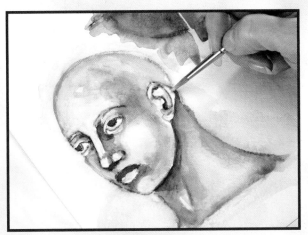

## 7 Strengthen the Highlights

Use white acrylic paint to add pop to highlight areas, including the nose, the ball of the nose, a little on the nostril, the lower lip, a bit around the ear, the collarbone, the shoulder, the chin, along the upper jawline (not underneath it), the upper eyelid and below the lower lid. Use a wet no. 8 round to blend the white into the other colors to create the tones you want.

If needed, redefine the facial details with a water-soluble pencil and reactivate with a wet brush.

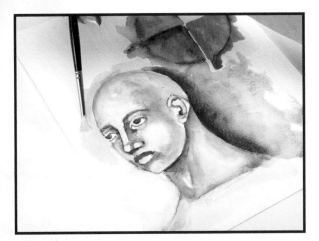

## 8 Strengthen the Shaded Areas

Add additional shade mixture as needed to further define the shadowed areas, including the background area on the right side of the face. Use a very wet no. 8 round. Add tint to the left side of the face, blending out with a wet brush.

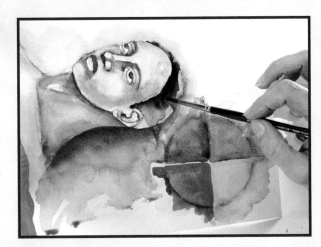

## 9 Add the Hair

Use a water-soluble pencil to add the hairline. You can dip the pencil into water to make the lines darker. Use a wet no. 8 round to blend out the hairline from the pencil. Let the hair flow into everything else.

## 10 Add Stenciling and Journaling

Place a stencil over the background, and use a baby wipe to remove the paint through the stencil design for a "reductive" stencil method. Emphasize the design by adding paint through the stencil as well.

You can use pens to journal on the page if you like. I added a note about the color I used.

vision is what you see when your eyes are closed

PROJECT 5

# WAXING PANPASTELS

PanPastels are an easy, gorgeous and fun medium to work with, and by adding an encaustic layer, the pigment will be fixed in paintlike beauty on the paper. Adding a touch of wax to your mixed-media work doesn't have to be hard or messy. Furthermore, PanPastels create little to no pastel dust, so these two mediums pair well and create amazingly beautiful artwork with little mess.

## MATERIALS

### Surface
7" × 5½" (18cm × 14cm) Fabriano Tiepolo printmaking paper

### PanPastels
Burnt Sienna, Burnt Sienna Tint, Payne's Gray, Raw Umber, Titanium White, Yellow Ochre

### Brushes
no. 8 round

2-inch (51mm) flat

### Other Supplies
encaustic medium, Enkaustikos Hot Cake, heat tool (optional), lightbox, melting pot or hot plate, paper towel, permanent black pen, Sofft Tools palette knife and sponge tips, Stabilo All black pencil or other water-soluble pencil

## 1 Trace a Face
Trace or draw a face onto Tiepolo paper, using a Stabilo All pencil or another water-soluble pencil and a lightbox. Journal with a permanent black pen if desired.

## WHY TIEPOLO?

Fabriano Tiepolo printmaking paper is strong and versatile. It is 140-lb. (300gsm), 100 percent cotton rag, neutral pH, chlorine- and acid-free, and comes in sheets 22" × 30" (56cm × 76cm) with four deckle edges. I use this paper for my printmaking projects and found it also works well with PanPastels and holds up extremely well to encaustic medium.

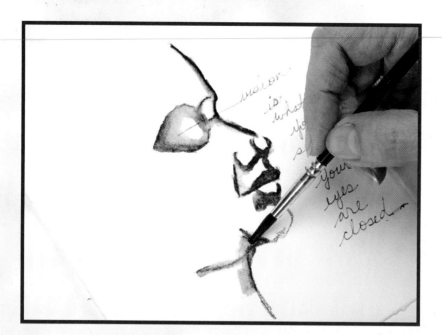

## 2 Activate the Pencil Lines

Activate the pencil using a wet no. 8 round. Rinse the brush often to keep it from getting too dark. Pull the pencil lines out to shade a little bit. Let air dry or use a heat tool.

## 3 Add the Highlights

Define highlighted areas with Titanium White PanPastel, patting it on with a Sofft Tool sponge applicator. Make a couple of swipes to lift the pastel onto the sponge applicator, and then pat the pastel onto the paper with short strokes. Add highlights to the forehead, cheekbone area, lower lip area, chin and jawline. Use a paper towel to clean off the Sofft Tool.

## PERFECT PARTNERS

PanPastels and Sofft Tools are a perfect pairing.

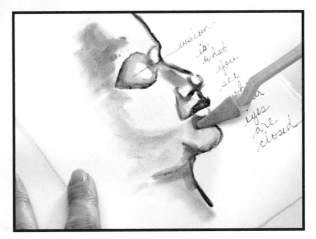

## 4 Add Shading

Lift a little Yellow Ochre with one swipe of the Sofft Tool, then add a swipe of Raw Umber. Apply this shade color with small pats to the left of the eye socket, around the back side of the cheekbone, underneath the cheekbone and on the side of the nose. Reload the applicator as needed. Continue shading underneath the jaw on the neck. Once you've applied the Yellow Ochre/Raw Umber mixture, use the applicator tool to blend it into the white highlight areas.

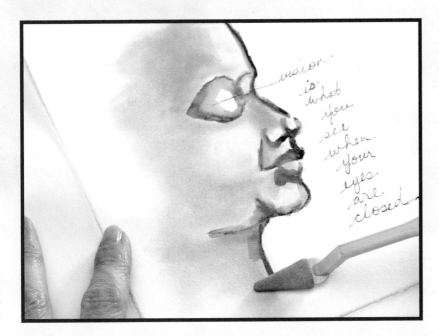

## 5 Add the Midtones

Develop midtones with a mixture of Burnt Sienna Tint and Burnt Sienna. Mix the PanPastels directly on the paper with the areas of Yellow Ochre and Raw Umber and into the white area, but don't cover all of the white (save the highlights).

## 6 Emphasize the Shaded Areas

Clean the applicator, and use Payne's Gray to further enhance shaded areas, particularly in the eye socket area, on the upper lip, beneath the lower lip and under the chin. Redefine the white highlights as needed.

## ABOUT ENKAUSTIKOS HOT CAKES

Hot Cakes are encaustic paints made from damar resin, beeswax and pigments that come in a refillable metal tin. (The encaustic medium used in this project is damar resin and beeswax with no pigment.) They are easy to use, less messy than traditional encaustics and contain no bleach or synthetic adulterants.

The tin is designed be placed directly on a hot plate or melting pot; just unscrew the lid and peel off the label on the bottom of the tin. They melt between 150–175° F (66–79° C). When you're finished with the Hot Cakes, let the medium cool and then replace the lid to keep it clean and free of dust.

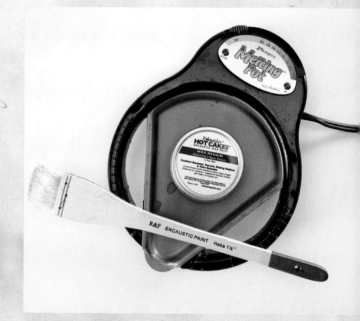

Visit CreateMixedMedia.com/Mixed-Media-Portraits for FREE bonus materials.

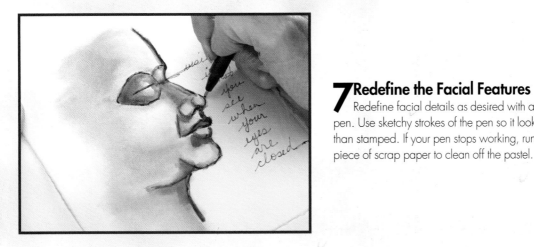

## 7 Redefine the Facial Features

Redefine facial details as desired with a permanent black pen. Use sketchy strokes of the pen so it looks drawn rather than stamped. If your pen stops working, run it over a clean piece of scrap paper to clean off the pastel.

## 8 Apply the Encaustic Medium

Heat the encaustic medium to 150–175° F (66–79° C) on a hot plate or in a melting pot (don't use something you cook on!). Using a cheap 2-inch (51mm) flat brush, apply the encaustic medium using continuous strokes from the bottom to the top of the paper, laying the brushstrokes right next to each other. Avoid overlapping the brushstrokes.

### FIXING DRIPS

If you have an encaustic drip, use a heat tool to melt the drip. It will flatten out as it melts. Alternatively, you could use a dedicated quilting iron to melt and flatten the drip.

PORTRAITS

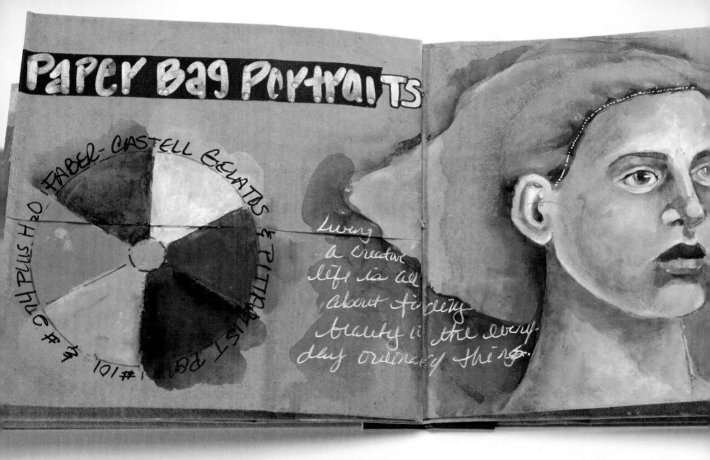

Paper Bag Portraits

FABER-CASTELL GELATOS
#101 PLUS H₂O
PITTRAIST PENS #3

Living a creative life is all about finding beauty in the every day ordinary things.

PROJECT 6
# PORTRAITS IN THE BAG

Working on toned paper can produce striking work with minimal effort, as the midtone is already present. By working on ordinary paper bags with fun and forgiving Gelatos, you get the benefits of toned paper without the expense or fear factor. These paper bag books create fun little pockets that can hold sketches, notes and inspirational images.

## MATERIALS

**Surfaces**
3 12" × 6" (30cm × 15cm) paper bags
2 pieces of chipboard (or sturdy cardstock) cut to fit the folded paper bag

**Brushes**
no. 8 round
1-inch (25mm) flat

**Faber-Castell Gelatos**
Brown, Flesh, Ochre, Sienna, White, Yellow

**Faber-Castell Big Brush Pens**
White and Warm Gray

**Other Supplies**
assorted journaling pens, awl, blending stump, bone folder tool, bookbinding needle, cloth tape, graphite transfer paper, heat tool or hair dryer, kneaded eraser, Mixed Media Adhesive or clear gesso, pencil, permanent black pen, scissors, scraper tool, stylus, wax paper palette, waxed linen thread, Yes! or other paper glue

## 1 Fold and Score the Bags
Make three folios by folding three paper bags in half. Score each fold with a bone folder tool. If the bags are wrinkled, you can iron them at this point to make them nice and flat.

## HELPFUL TOOLS

You'll need Gelatos, Big Brush pens, assorted journaling pens, a blending stump and a kneaded eraser for this project.

## 2 Nest the Bags and Pierce the Spine

Nest the folded bags inside of each other, alternating the closed and open ends of the bags. Use an awl to punch three holes into the spine, one in the center and one in the top and bottom about 1 inch (25mm) from each end. Cut a piece of waxed linen thread roughly two times the length of the paper bags, and use a pamphlet stitch to bind the pages (see below).

## PAMPHLET STITCH INSTRUCTIONS

1. Go in through the middle hole from the inside.
2. Flip the book over and go through the top or bottom, leaving a 3-inch (8cm) tail on the inside.
3. On the inside, go through the hole on the opposite end of the page.
4. Flip the book, and go through the middle from the back.
5. Take the tail on one side of the long stitch and the other tail on the other side, and tie a square knot over the long stitch. Trim the tails.

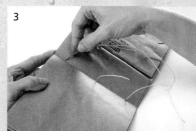

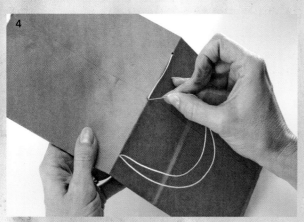

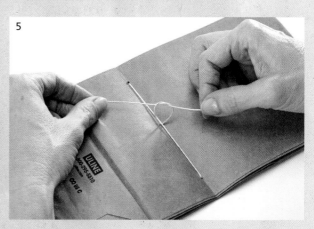

## 3 Attach Chipboard Covers

Apply a bead of Yes! glue or other thick paper glue along the edge of the scraping tool or an old credit card. Holding the scraping tool at an angle, spread a very thin layer of glue on one exterior side of the book and on one of the pieces of chipboard. Repeat with the other exterior side. There will be a ½-inch (13mm) gap on either side of the spine, but make sure the chipboard covers the exterior edges.

## 4 Cover the Spine

Cover the spine with cloth bookbinder's tape. Cut approximately 7½ inches (19cm) of tape so it is long enough to cover the spine with about ½ inch (13mm) extra on either end. Apply the tape to the spine, burnishing the tape with a bone folder tool. Tuck the ends under the edges of the exterior bag pages.

## 5 Prep the Pages

Prep the pages with Mixed Media Adhesive or clear gesso and a 1-inch (25mm) flat. Drybrush it on to avoid overly saturating the page. Use a crisscross pattern to create random strokes. Don't worry about covering the page completely edge to edge. Prep all of the pages, then let dry.

## 6 Draw a Color Wheel

On the first book page, draw a color wheel with a permanent black pen. You can use a stencil or draw the wheel freehand. Apply the Gelatos directly to the wheel, coloring outside the lines a bit for added visual appeal. Then use a wet no. 8 round to activate the crayon. You can activate the colors as you apply them or apply them all first and then activate them all at once. This will allow you to see how the colors look on the paper bag. Let air dry or dry with a heat tool.

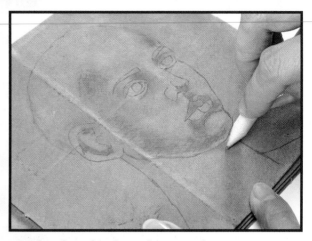

## 7 Transfer Sketches

Transfer sketches to the pages, one per spread, using graphite paper. Place the graphite paper on the page, then lay the sketch on top. Use a stylus just as you would a pencil to trace the lines, adding crosshatch shading to the face while tracing.

## 8 Blend and Adjust the Transfer

Use a blending stump to blend the graphite transfer marks, shading the face.

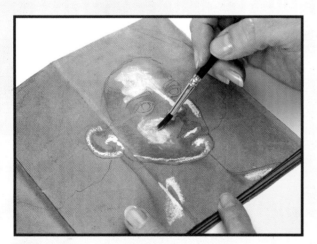

## 9 Establish the Highlights

Use a pencil to add hairlines and a kneaded eraser to lift unwanted graphite marks. Add highlight areas, applying White Gelatos directly to the sketch. Add highlights to the forehead, nose, cheekbones, jawline, ears, the whites of the eyes, and the upper and lower eyelids. Apply the color lightly, allowing the paper bag to show through. Activate it with a wet no. 8 round. Avoid overly saturating the paper bag. Dry with a heat tool or let air dry.

## LET IT DRY

Let the pages dry between each step so the bag doesn't become overly saturated. You can use a heat tool to speed things up, but be careful not to get too close to the bag, and keep the heat tool moving.

98

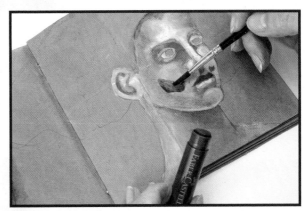

## 10 Establish the Shading

Add shaded areas, applying Yellow Ochre Gelatos directly to the sketch. Shade the inside corners of the eyes, under the nose, under the lower lip, under the chin, under the cheekbone area and around the hairline. Activate the Yellow Ochre with a wet no. 8 round, and blend it into the White.

While the page is still wet, drop in additional shading with Brown Gelatos by touching a wet no. 8 round to the tip to lift color. Apply the Brown to the inside corners of the eye, the inner ear folds, under the nose, the upper lip, under the lower lip and under the chin. Let the page air dry or dry with a heat tool.

## 11 Establish the Midtones

Create the midtones with the Flesh Gelatos. Apply the Flesh color directly to the page between the highlights and shaded areas. Activate with a wet no. 8 round and continue to blend with the colors laid down previously. Add Sienna Gelatos to the cheek area and lips by touching a wet no. 8 round to the tip of the Gelatos and then painting it onto the face. Using the brush to apply color gives you more control in small areas and creates more intense colors.

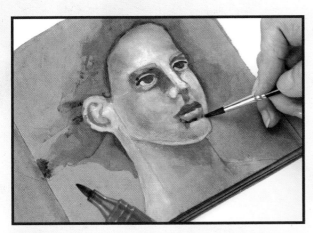

## 12 Add the Final Details and Journaling

Use a Warm Gray Faber-Castell Big Brush pen to color around the hair and face, one small section at a time. Then activate the ink with a wet no. 8 round, letting it pool and drip a bit. Once dry, it's permanent, and you can write over it with a White Big Brush pen. You can use the Gray to add details to the eyes and lips. Use the White pen to add highlights to the hair and other areas, and activate with a wet brush as before. Add journaling, notes and whatever you like to fill the journal. You can also add additional paintings, sketches or notes to the pockets formed by the paper bags.

### A NOTE ABOUT BIG BRUSH PENS

Faber-Castell Big Brush pens in White and Warm Gray are two of my very favorite art tools because of their versatility. They are great for adding journaling and finishing details. You can apply them directly to a substrate and then move the ink around like paint to add shading and highlights. Because they are filled with India ink, they are permanent when dry.

You can also color the pen on a wax paper palette and lift it with a wet brush. This will give you a bit more control if you're concerned about the color drying before you've had time to activate it. All of the colors available are wonderful, but even just these two will add so much dimension to your portraits.

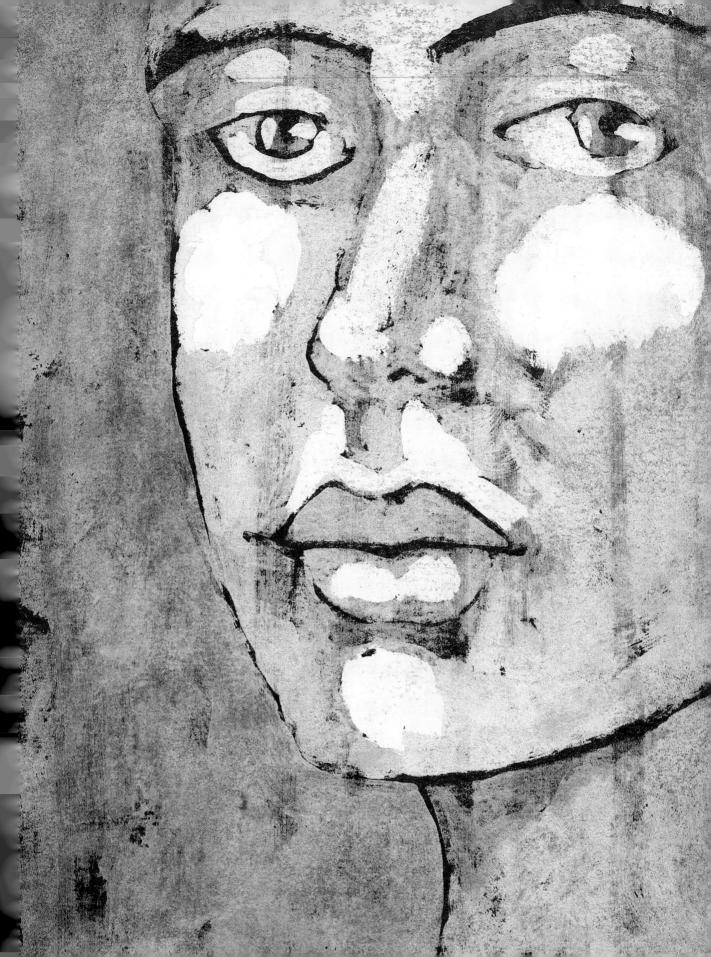

PROJECT 7

# RESISTING GOUACHE

This process always reminds me of combining the paint-by-number and scratch art that I made when I was young. First you will block in the colors side by side, then you'll cover the whole thing with ink and rinse to reveal the final image. It's fun because you never know exactly what the outcome will be, and it takes a little bravery to cover your painting with ink. I think these pieces have the look of wood- or linoleum-block prints, but they don't require nearly as much time or effort.

## MATERIALS

**Surface**
8" × 6" (20cm × 15cm) 300-lb. (640gsm) cold-pressed watercolor paper

**Gouache Paint**
Sienna, Violet, White, Yellow Ochre

**Brushes**
2-inch (51mm) flat
no. 6 round

**Other Supplies**
2H pencil, dry wax deli paper or newspaper, gloves, India ink, lightbox, painter's tape, palette, pan of water or sink, small disposable container

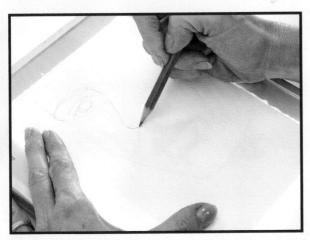

## FAUX BLOCK PRINTS

Caran d'Ache Gouache and India ink create the look of a block print.

### 1 Trace a Sketch
Lay a sketch under 300-lb. (640gsm) cold-pressed water-color paper on a lightbox and trace with a 2H pencil to create light lines.

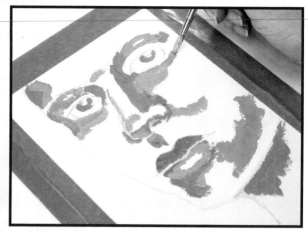

## 2 Tape Down the Paper

Tape the paper to your work surface, overlapping all the edges of paper by ¼–½ inch (6–13mm) to create a border.

## 3 Apply the Gouache in Color Blocks

Paint on gouache blockstyle with a no. 6 round, laying the colors next to each other rather than overlapping them. Don't thin the paint—apply it thickly so it will block the ink. Leave space unpainted around all of the line details. Remember that the color you lay down first is the color that will show in the final painting. Any subsequent colors laid on top won't show.

Apply White to the highlight areas, including the whites of the eyes, eyelids, nose, above the upper lip, below the lower lip, the ball of the chin and the jawline with a dry no. 6 round. Avoid covering the pencil lines.

Mix Yellow Ochre and White on the palette, and paint the mixture in blocks around the white highlights with a no. 6 round.

Mix Violet and White on the palette, and paint the mixture in the shadow areas, including the inside corners of the eyes, the irises, around the bottom of the nose, the bottom of the upper lip, underneath the lower lip and underneath the chin.

Mix Sienna with White on the palette to form several skin tones. Paint the darker skin tone mixture beside the nose, underneath the nose, on the upper lip and a little bit on the outer edges of the lower lip. Paint a midtone skin color above the eye, under the eye and a little on the lower lip (up to the white highlight). Use light skin tone to fill in everything else, leaving the pencil lines open for the black ink. It's OK if you overlap the white highlights a bit as long as you don't scrub or you may remove paint.

## PRACTICE ON A COLOR WHEEL

Make a gouache-resist color wheel to see how the colors show once rinsed and to get the hang of the technique. This will help you determine how dark you want the gouache colors to be. They will come out lighter than they look originally. You can see in this portrait that the colors were a little too light.

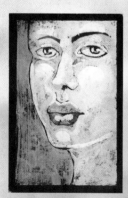
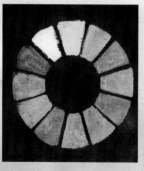

### Practice Makes Perfect

Lightly draw a color wheel with a pencil on a piece of water-color paper. Apply gouache colors to each space and let dry. Apply a layer of India ink over the entire paper and let dry overnight. Rinse off the gouache and see how the colors look to determine which ones you might want to use in your portrait.

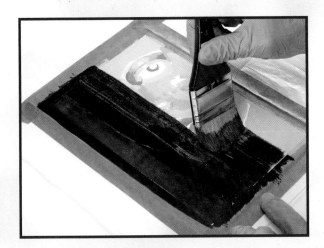

## 4 Cover the Painting With Ink

Wear gloves and protect your work area and clothes for this step. Lay the painting on top of dry wax deli paper or a stack of newspaper. Pour the India ink into a small disposable container. Use a cheap 2-inch (51mm) flat brush to apply India ink at full strength. Apply the ink gently, painting one even stroke from the bottom to the top. Lay the next stroke right beside the first, trying not to overlap or go back and forth in the same area (overworking may remove the gouache). Let air dry, preferably overnight. The gouache may crack a bit as it dries, but this is normal.

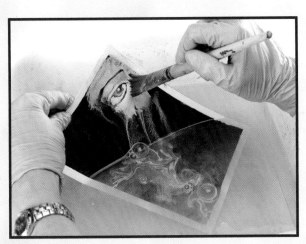

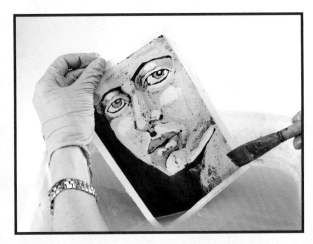

## 5 Remove the Tape and Ink

Gently peel off the tape from the edges of the painting. Rinse the ink from the painting in a pan of warm water or in a sink with a steady stream of water or a spray nozzle. Rinse off as much as you like. Let the painting dry completely on a flat surface.

## BORDER OPTIONS

If you want a black border, remove the tape before applying the ink. If you prefer a white border, remove the tape after applying the ink.

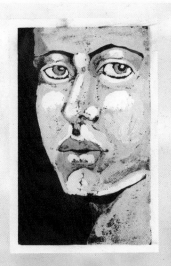

103

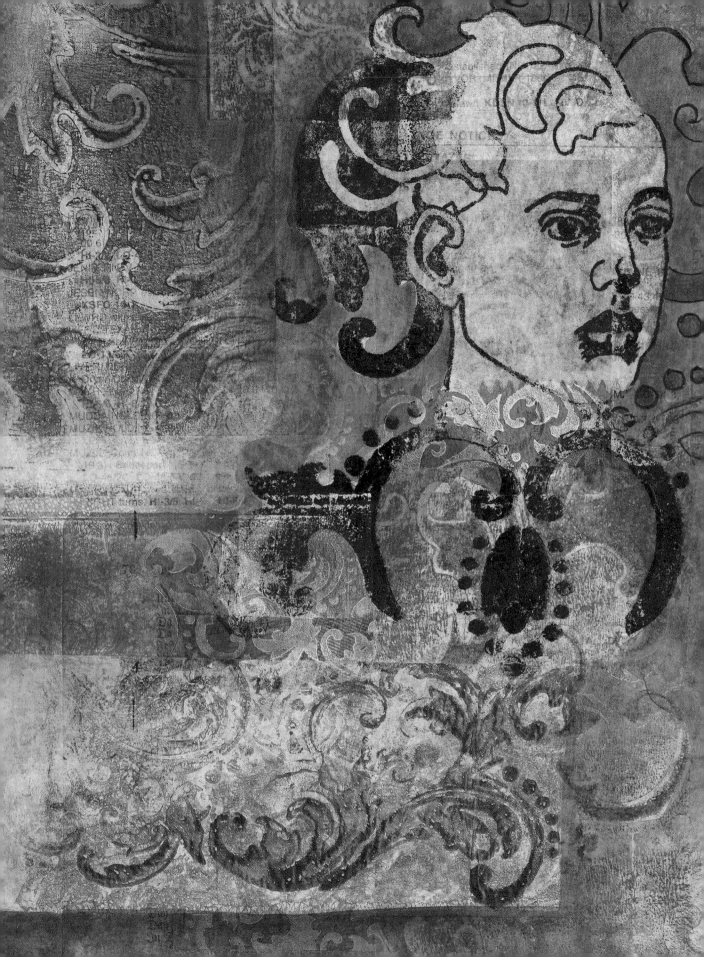

# POLYESTER PRINT PLAYGROUND

For this project we'll work with an easy-to-use polyester alternative to the traditional stone lithographic printing plate. This is a low-tech adaptation of lithographic printmaking that makes fine art printing doable for anyone. With polyester lithographic print plate, some pens and the ever-fun Gelli plate, you can take printmaking surface design in a whole new mixed-media direction! Try printing more than one plate onto a background or only partially inking up a plate for a more distressed look that resembles image transfers. The possibilities are endless.

## MATERIALS

**Surface**
10" × 8" (25cm × 20cm) Tiepolo paper

**Matisse Acrylic Paint**
Southern Ocean Blue, Transparent Umber, Transparent Venetian Red, Transparent Yellow Oxide or brands and colors of your choice

**Brushes**
1-inch (25mm) flat

**Other Supplies**
baby wipes, baren or plastic/wooden spoon, black graphic chemical lithography ink, citric acid powder (might be necessary), dish soap, dry wax deli paper, Faber-Castell Pitt Artist pens, Gelli plate, gesso, gum arabic (might be necessary), hot plate (or iron or oven), lightbox, Mixed Media Adhesive, neutral collage materials, newsprint paper, open medium, palette, paper towels, Plexiglas or acetate sheet, polyester lithographic print plate, rubber gloves, Simple Green cleaner/SoHo studio wipes, soft and hard rubber brayers, spatula, sponge, spray bottle, stencils, water bowl

## 1 Collage Papers on the Substrate

Collage thin papers onto a sturdier Tiepolo paper substrate, using a 1-inch (25mm) flat and Mixed Media Adhesive. Apply the adhesive to the back of the collage papers, to the substrate and then over the top of the applied papers. Use neutral collage papers, and don't cover the substrate completely. Use the brush to work out all the air bubbles. If you used an adhesive other than Mixed Media Adhesive, apply a coat of clear gesso to the entire surface. Let dry.

## 2 Stencil Over the Collaged Background
Lay a stencil over part of the collaged background, and use a sponge dauber and gesso to stencil the design. Let dry. This will create a resist effect to the paints used later.

## 3 Prepare the Gelli Plate
Prepare a stack of dry wax deli paper to print from, a palette for your paint, a soft rubber brayer and some open acrylic paint or acrylic paint mixed with a small amount (10:1 ratio) of open medium. The open acrylics or open medium will give you more working time with the paint. I used Transparent Venetian Red for this step, but you can use any color of your choice. Use a soft rubber brayer to apply the paint mixture to the Gelli plate.

## ABOUT GELLI PLATES

Gelli Arts® Gel Printing Plate is durable, stores at room temperature and is easy to clean. Monoprinting on gelatin plates creates a unique result popular with many printmakers. While gelatin plates ultimately deteriorate, Gelli plates are reusable. They look, feel and react like a gelatin plate, but are made of a unique plastic that contains mineral oil. Acrylic paint, water-soluble inks and fabric paints work best to create interesting one-of-a-kind monoprints—no printing press required!

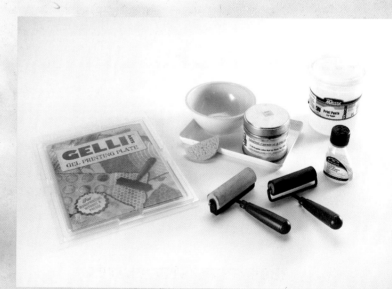

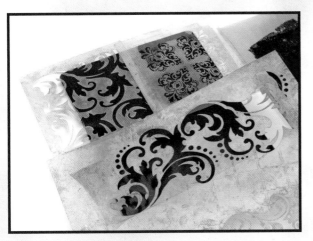

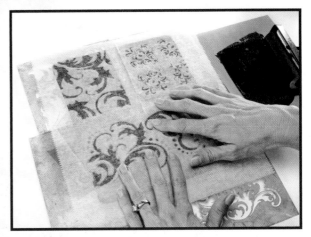

# 4 Make the Prints

When I'm printmaking, I print more sheets than I'll need so I have a constant stash of papers to pull from. Pull as many prints as you like, but you will want at least three to work with for this project. Lay coordinating stencils on the Gelli plate, and pull a print using dry wax deli paper. Press the paper with your hands to help transfer the print. Set the print aside to dry.

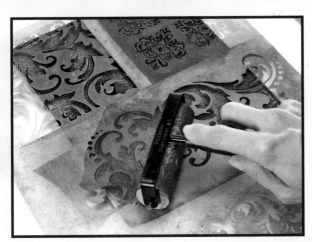

# 5 Add a Second Color and Make More Prints

Clean the brayer by rolling it on a paper towel. Add Transparent Yellow Oxide or another color of your choice mixed with open medium to the brayer and roll over the stencil-covered Gelli plate. Remove one or more of the stencils, and pull another print on deli paper. Remove all of the stencils, and place another piece of deli paper on the plate to pull a final print. Let all of the prints dry.

## ABOUT POLYESTER PLATES

Polyester lithographic print plates are heat-resistant and semitransparent. The polyester surface mimics the surface of a lithographic stone or plate. There are several brands on the market, and they are inexpensive, fast and flexible. They require very little processing and work well for monoprinting or small-edition print runs.

## 6 Paint the Background

Mix a thin wash of Transparent Yellow Oxide, and apply the paint to the entire background of the collaged substrate with a 1-inch (25mm) flat. Let dry for a couple of minutes, then run a baby wipe over the gessoed area to reveal the gesso.

Note: The different types of paper used for the collage may each take the paint differently. This is part of what makes this process so interesting and why you want to leave some of the background bare.

## 7 Collage the Printed Papers

Collage the dry printed papers onto the background. Apply the papers with a 1-inch (25mm) flat and Mixed Media Adhesive. Apply the adhesive to the back of the papers, to the substrate and then over the applied papers. You can flip over some of the collaged papers to create lighter and darker areas. Apply a plain piece of unprinted dry wax deli paper roughly the size of the face image you're going to print in the desired location. This will allow the underlying layers to show through without overwhelming the printed image.

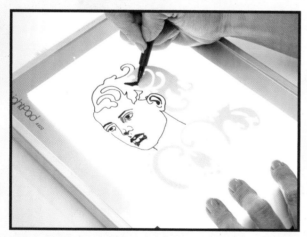

## 8 Transfer Your Design to a Print Plate

Sandwich the design between a lightbox and an polyester lithographic print plate, making sure the rough side of the plate is facing up. You should be able to see the design through the plate. Use assorted Pitt Artist pens to trace the design onto the plate, reserving at least a 1-inch (25mm) border around the design.

## INCORPORATING STENCILS

When tracing the face onto the polyester lithographic print plate, you can add some of the stencil design elements from the stencils you used in the background. I added some hair that was actually part of the stencil pattern and also for the top of her clothes. This helps tie the printed image to the background.

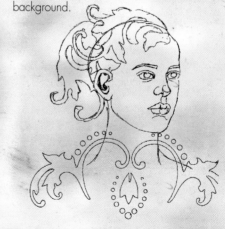

Visit CreateMixedMedia.com/Mixed-Media-Portraits for FREE bonus materials.

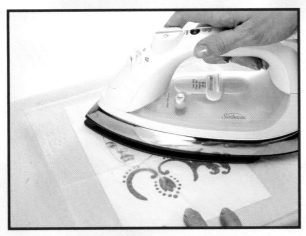

# 9 Set the Print Plate

Heat-set the plate in an oven, with an iron or on a hot plate at 225–250° F (107–121° C) for 10 minutes. When the print plate has cooled, wash it with a sponge and a tiny drop of dish soap to remove any oils or dirt transferred from your hands.

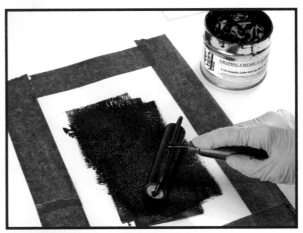

# 10 Prepare the Print Papers and Ink the Brayer

Prepare a small stack of newsprint paper cut to the same size as the print plate. For an inking plate, you can use a piece of Plexiglas or an acetate sheet taped to your work surface. Wearing rubber gloves, put a small amount of litho ink on your inking plate. Work it with a spatula for a few minutes. Use the hard rubber brayer to roll out the ink, using crisscross strokes. You'll hear a smooth hissing sound when your brayer is fully charged with ink.

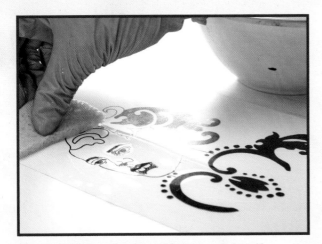

# 11 Wet the Work Surface and the Plate

Spritz the worktable and lay the polyester lithographic print plate on the wet surface to help hold it in place. Now dip a sponge in wiping water (see sidebar on how to mix this solution), squeeze and pass lightly over the plate a few times. The pores of the plate surface that aren't closed with pen ink now fill with water that will repel the ink from the brayer.

## MIXING WIPING WATER

Fill a plastic bowl (cereal bowl sized) with water and add 1 oz. (30ml) of gum arabic solution and half a teaspoon (2.5ml) of citric acid powder. You can find gum arabic in art stores and citric acid powder in the canning section of the grocery store.

You can try using distilled water, but if you get scumming (smudges of ink on the plate), you'll need to use the wiping water mixture.

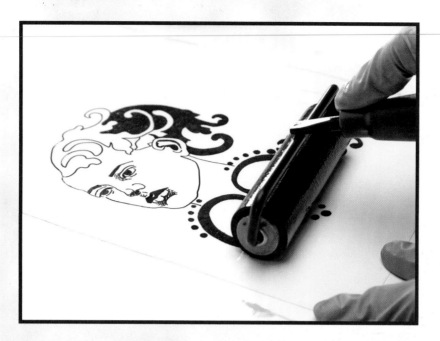

## 12 Ink the Plate

Run the ink-charged brayer over the print plate with a light hand. Wet the plate again as in Step 11 and run the brayer over the plate again. Repeat these two steps several times to completely ink the plate. The initial inking may take four to ten water/ink cycles. Subsequent inkings will take fewer cycles.

Note: If ink gets on the white areas of the print plate (this is called "scumming"), use the wet sponge to rub it off.

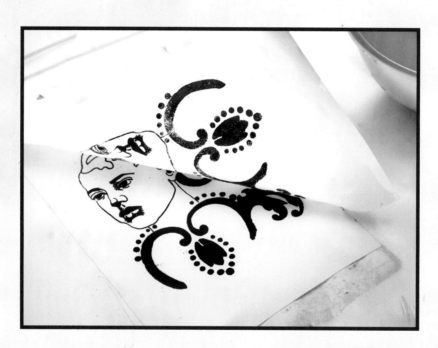

## 13 Make Test Prints

Prepare the background substrate with a light spritz of water. (You want the paper damp, softened up just a bit, but not wet.) Lay a piece of the newsprint on top of the inked plate and burnish with a plastic rubbing spoon, wooden spoon or baren. Try making a test print with each type of burnishing tool to see which works best for you. Reink the plate between each test print.

## HELP! MY PRINT DIDN'T TURN OUT!

That's OK! Take a deep breath. This isn't fine art, and you don't need a perfect print. Embrace the imperfection and work with it. There are several things you can do to make a messed-up print work. You can draw any important missing details with a black pen or let a partial image that has an old, timeworn look fade into the background. If all else fails, you can add a bit more collage over the printed area and have another go at it.

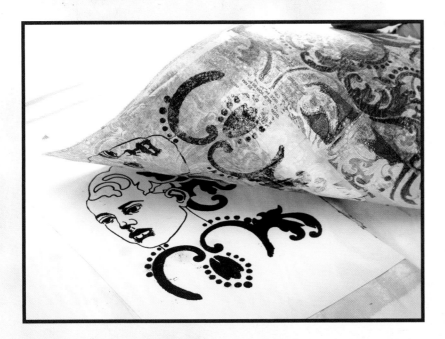

## 14 Make the Final Prints

When you begin getting good test prints, it's time to print your final images onto the background substrate. It may take a few days for the ink to fully dry, so lay the prints where they won't be disturbed.

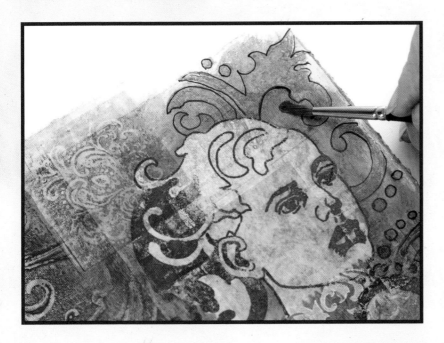

## 15 Enhance the Background

To further enhance the background and tie it into the print, use the black Pitt Artist pen to retrace some of the stencil lines on the background around the printed image. Add a little more acrylic paint around the outside edge of the traced design to make the image pop

## CLEANING UP

Clean the brayer and Plexiglas or acetate sheet with SoHo studio wipes or Simple Green nontoxic cleaners. Just run the brayer over the wipes.

Clean the polyester lithographic print plate by first printing over and over onto newsprint until the ink is mostly gone. Then clean thoroughly with liquid dish soap. Don't use chemical cleaners on the print plate.

Store your print plates flat in a drawer. They will last a long time if properly cleaned and stored.

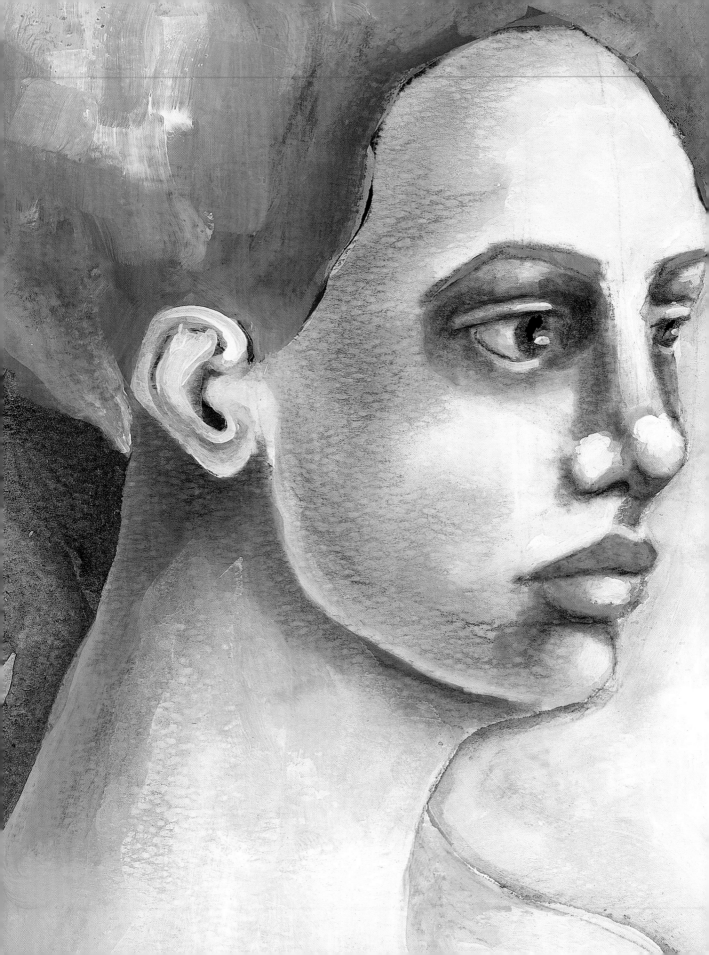

PROJECT 9
# SKIN TONES

Several years ago I ran across a small set of Conté crayons at an art store and decided to give them another try. I'd remembered having to use them in my high school art class and not liking their square shape. It bugged me that I'd never gotten the hang of using them, so I began playing with them to see what they could do in mixed-media applications. I found that I love them! I've completed entire sketchbooks with them, and I especially love the technique you'll learn in this project. These little crayons pack a lot of pigment punch, and the basic colors create lovely portrait work.

## MATERIALS

**Surface**
8" × 6" (20cm × 15cm) 140-lb. (300gsm) cold-pressed watercolor paper

**Conté Crayon**
Black, Brown, Sanguine, White

**Brushes**
1-inch (25mm) flat
no. 8 round

**Other Supplies**
gesso, lightbox or scanner/printer, pencil

## 1 Trace or Scan a Sketch
Place watercolor paper over your sketch on a lightbox and trace lightly with pencil (see "The Real Hue" demo for further instruction) or scan and print the sketch on inkjet watercolor paper. (I used Strathmore inkjet paper for my print.)

### ABOUT CONTÉ CRAYONS

Conté crayons were invented in 1795 by Nicolas-Jacques Conté in France. Conté crayons were originally made from compressed powdered graphite or charcoal mixed with a wax or clay base. They are now manufactured using pigments such as iron oxide, carbon and titanium oxide combined with clay and a binder. They are usually square but are also available in pencil form.

## 2 Add the Midtones

Color the midtone areas with Sanguine Conté crayon (you can use blocks or pencils). You don't need to be precise or use a heavy hand. Add color around the outside of the head, around the inside of the forehead area, down the cheekbone, the eye socket area, the side of the nose, under the nose, the upper lip, under the lower lip and under the chin.

## 3 Mix the Midtones and Add Highlights

Use gesso and a wet no. 8 round to mix the midtones directly on the paper. I used a low-viscosity gesso, but any gesso will work, though you will need to thin thicker gessos with water. Wet the brush frequently and add gesso as needed. Varying the amount of gesso will help you develop many tones. For the highlight areas, including the forehead, brow bone and nose, rinse your brush and go to straight gesso. Let dry.

## ALTERNATE COLOR PALETTES

Feel free to use different color palettes for this portrait. Here are some alternate palettes that you can try and an example of a grayscale portrait. You can trace the color wheel template at the end of the book to test your own palettes.

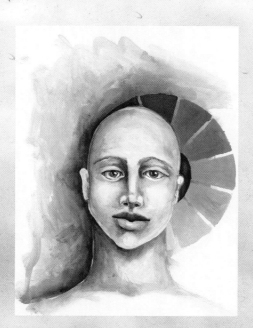

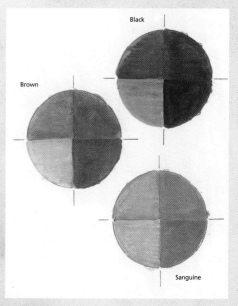

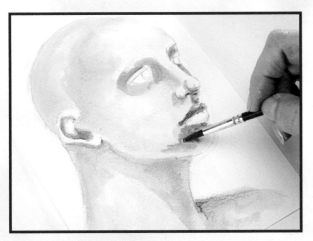

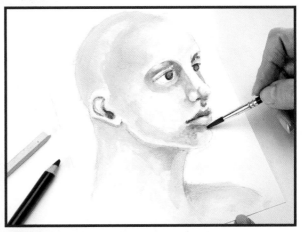

## 4 Add the Shadows
Use Brown Conté to deepen the shadows around the eye sockets, the inner corner of the eye, under the nose, the upper lip, under the lower lip and under the chin. If you're concerned about how dark the color will be, start under the chin. Activate the color with gesso and a wet no. 8 round as in Step 3.

## 5 Accentuate the Highlights and Shadows
Add White and Black Conté to make things pop. Add White to all the highlight areas, including the brow bone, forehead, nose, above the upper lip, on the lower lip, the cheekbone, chin and jawline. Add tiny touches of Black to the inner eye, the upper eyelids, the irises, the inner ear, nostril and the midline of the lip. Activate all the new color with a wet no. 8 round and a very small amount of gesso. Rinse the brush frequently if it starts to get too dark.

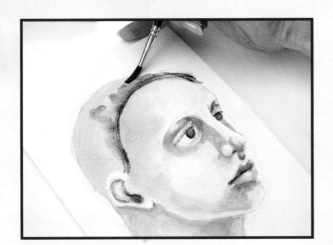

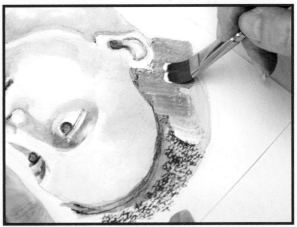

## 6 Add the Hair and Background
Use Black Conté to establish the hairline. Activate the color with a wet no. 8 round and gesso, pulling the line out toward the hair. Color Sanguine (or whatever color you chose) onto the background. A block works well for the background. Use a 1-inch (25mm) flat to pull blocks of color to create the hair. Load with gesso as needed, making it lighter as you move out from the hairline. Continue painting the background with more Conté and gesso as desired.

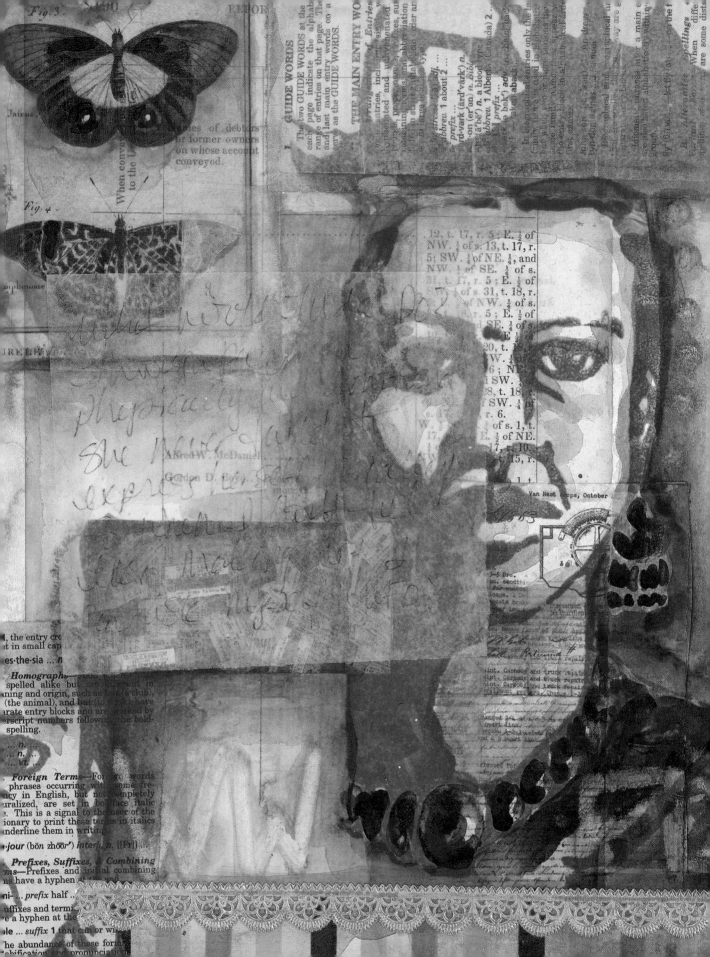

# FACING THE THERMOFAX

Thermofax screens are a wonderful way to make multiple images of one of your sketches or photos. It doesn't require an expensive machine as there are many places online that will make custom screens of your designs for a reasonable price. See Part 2 of this project if you want to go old-school and make your own screen from scratch. Whichever way you decide to play, screenprinting on paper is a fun way to explore your sketches as you combine them with mixed-media techniques.

## MATERIALS

**Surface**
11" × 7½" (28cm × 19cm) Tiepolo paper

**Acrylic Paint**
colors of your choice

**Brushes**
1-inch (25mm) flat
no. 8 round

**Other Supplies**
clear wax crayon, dish soap, dry wax deli paper and book pages for additional prints, extra print paper, Matisse print paste, Fluid Matte Sheer Acrylics or acrylic washes, Mixed Media Adhesive, neutral collage materials, palette, palette knife, paper towels, shallow water pan, soft brush (corncob or other), squeegee, Thermofax screen

## FACTS ON THERMOFAX

Thermofax is 3M's trademarked name for a photocopying technology that was introduced in the 1950s. A screen is created by placing a thin sheet of heat-sensitive copy paper over the design and exposing it to a special lightbulb. Thermofax machines are still widely used by textile and printmaking artists.

### 1 Collage the Background

Use Mixed Media Adhesive or gel medium to adhere collage elements to the Tiepolo paper. Apply the adhesive with a 1-inch (25mm) flat to the back of the elements, to the substrate and then over the top of the elements once you've applied them. Make sure all of the collage materials are neatly and securely glued down, but you don't need to cover all of the substrate. Let dry.

## 2 Mix Acrylic Paint With Print Paste

Use a palette knife to mix print paste 1:1 with acrylic paint in a color of your choice (I'm using two parts Southern Ocean Blue to one part Cobalt Teal) on a palette. It will look "orange peely" at first and smooth when completely incorporated. You can make custom colors, using as many acrylic colors as you like.

## 3 Apply the Paint to the Thermofax Screen

Place a Thermofax screen right side up on the substrate. Use a palette knife to load a squeegee with the print paste mixture. Lay the squeegee tool on top of the bottom of the screen, holding it at an angle, and pull upward in one smooth stroke.

## 4 Test the Screen and Make Prints

Lift the screen, being careful to lift straight up to avoid smearing the image. Work on extra print papers first to make sure the image is well inked and to create additional materials to work with later. Print on the main piece when you're confident the screen is well-inked.

## 5 Wash and Dry the Screen

Wash the screen immediately (you can place it in a tub of water temporarily). Use a soft brush (I like corncob brushes) and mild soap with water to clean the screen. Remove all of the paint. The paint may stain the screen, which isn't a problem. Lay the screen flat on a towel to dry.

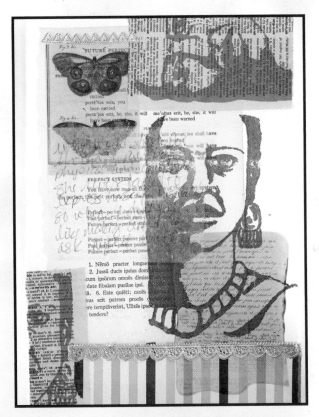

## 6 Continue Collaging

Add an additional layer of collage material, including interesting bits of papers and partial images of the prints pulled on various papers. You can also collage plain dry wax deli paper or journal on the deli paper and adhere that. Use Mixed Media Adhesive or gel medium and a 1-inch (25mm) flat to adhere, applying the adhesive to the back of the elements, to the substrate and then over the top of the applied elements. Let dry.

## 7 Add Clear Wax Crayon

Apply clear wax crayon to the areas of your design that you want to remain white. You can write words or doodle as well. I wrote, "WWFD?" (What would Frida do?)

## 8 Add Paint to Tie the Image Together

Use Fluid Matte Sheer Acrylics or acrylic washes and a no. 8 round to paint around the collage and print work. (I used Turquoise for added pop and Mustard Seed and Golden Rod for the background, tying the images together.) Use a lot of water for a watercolor effect, and let the paint dry between layers. Using a no. 8 round, apply very diluted paint over the wax crayon areas, and let it sit for a few minutes. The crayon will resist the paint, and you can blot with a paper towel to remove excess paint. Paint over the silk-screen prints and around them to tie them together with the collaged elements.

# ALTERNATE SILK SCREEN METHOD

This is a fun, low-tech way to make your own screens economically. With just a little time and effort, you'll have a screen that will produce many prints.

## MATERIALS

**Surface**
mesh-type material (nylon, polyester, silk—something with tiny holes)

**Brush**
no. 6 round

**Other Supplies**
black permanent pen, scanner/ printer, sink/sprayer or tub, soft brush (corncob or other), Speedball drawing fluid and screen filler, spoon, squeegee, wood screen frame or embroidery hoop

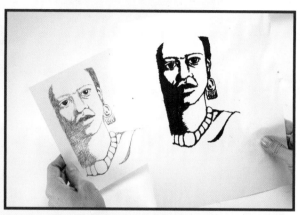

## 1 Scan a Sketch
Scan and resize your sketch to the desired size, and print a black-and-white copy.

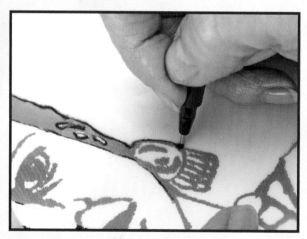

## 2 Trace the Sketch Onto the Screen
Assemble a frame or hoop with screen material, making sure it's stretched tightly. Flip the frame over so the screen is facing up with the sketch underneath. Trace the design on the fabric with a black permanent pen.

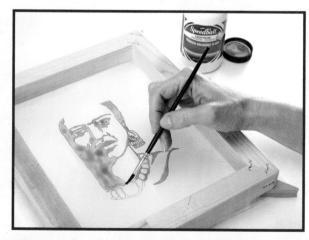

## 3 Paint the Sketch on the Screen
Prop the screen up over the copied sketch. Using a no. 6 round brush and drawing fluid, paint the sketch onto the screen. The sketch is your guide; your creation doesn't have to be an exact copy. The drawing fluid will be washed out later and these lines are what your printed image will look like. Let dry for about an hour.

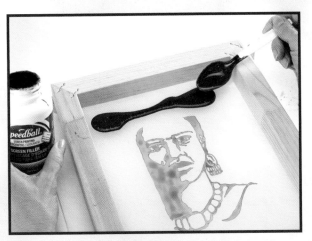
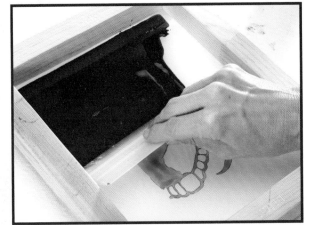

# 4 Apply Screen Filler to the Screen

Place newspapers or paper towels beneath the screen with the drawing fluid side up. Prop the screen frame up so it's not resting directly on the paper. Spoon a couple tablespoons (30ml) of screen filler on top of the screen. Using a squeegee, drag the screen filler at a 45-degree angle from the top to the bottom of the screen until it's covered. Note: The screen filler is what remains on the screen and masks off the areas you don't want ink to print through. If the screen filler bleeds through to the other side, use the squeegee to scrape it off. Let dry thoroughly, preferably overnight.

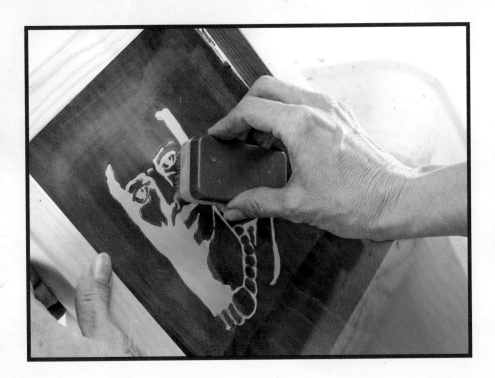

# 5 Rinse off the Drawing Fluid

Rinse the drawing fluid from the screen with a kitchen sink spray nozzle, or wash it off in a tub of water. You can use a corncob brush or other soft brush to remove the fluid, but be gentle so you don't harm the screen filler. Let dry. Proceed with the printing process as in Step 2 of Part 1.

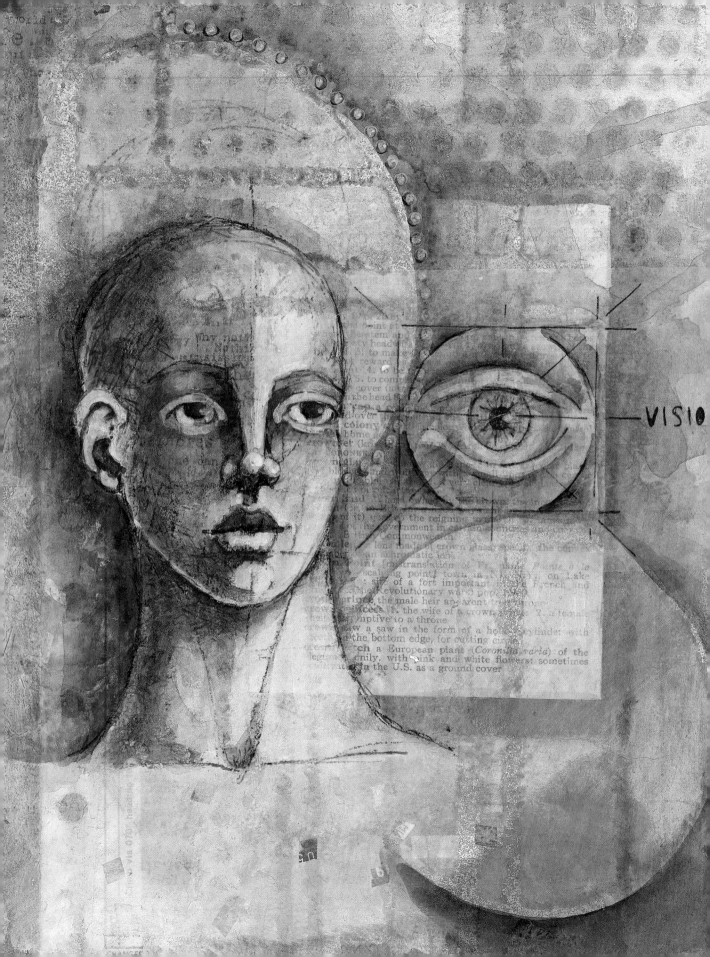

VISIO

# TRANSFER OVERLAY

Working on a previously prepared background allows interesting faces to emerge and for imagery, words, color and texture to play in them. Transparency transfers are a great element to add to a background, and you can continue to work on top of them. You can see through transparencies, so you can see exactly how it's going to look on the background before applying it. By scanning your sketches and resizing and printing them onto transparencies, you will have a whole host of imagery to use in your work!

## MATERIALS

**Surface**
10" × 8" (25cm × 20cm) plein air panel or 140-lb. (300gsm) hot-pressed watercolor paper

**Acrylic Ink**
colors of your choice

**Faber-Castell Pitt Artist Pen**
Black

**Faber-Castell Big Brush Pens**
Gray, White

**Fluid Matte Sheer Acrylics**
colors of your choice

**Brushes**
1-inch (25mm) flat
no. 8 round

**Other Supplies**
baby wipes, black permanent pen, bone folder tool or spoon, gesso, heat tool (optional), inkjet transparency printed with sketch, Mixed Media Adhesive or gel medium, neutral collage materials, scissors, spray bottles, stencils

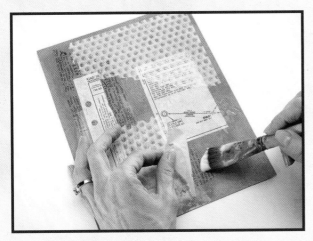

## 1 Collage the Background

Adhere thin neutral collage elements to the panel or water-color paper using Mixed Media Adhesive or gel medium. Use a 1-inch (25mm) flat to apply adhesive to the back of the elements, to the substrate and then over the applied elements, leaving some of the panel color to show through. Let air dry or use a heat tool to speed drying.

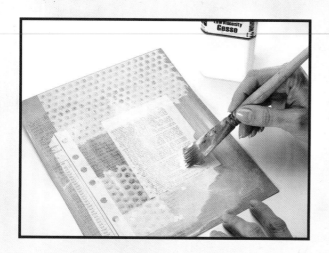

## 2 Apply Gesso to the Background

Apply a wash of gesso (1 part gesso to 4 parts water) over the collaged background with a 1-inch (25mm) flat, unifying the elements. It's OK to leave some of the background and edges without gesso. Let air dry or speed dry with a heat tool.

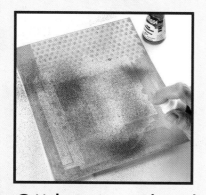 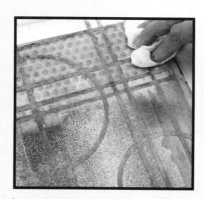 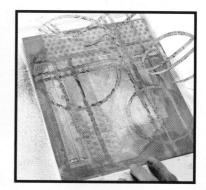

## 3 Make Designs With Acrylic Ink and Stencils

Attach a spray top to the acrylic ink bottle or transfer the ink into a small spray bottle. Spray the background with two colors of your choice (I'm using Turquoise and Mustard Seed). Note: test the spray before spraying onto your project.

Lay a stencil on top of the sprayed ink and use a baby wipe to blend and lift the ink. Remove the larger stencil and lay a smaller stencil on different areas of the background, wiping with a clean baby wipe.

### ABOUT STENCILS

To keep your smaller stencils organized and easy to find, punch a hole in the corner of each stencil with a hole punch tool and attach the stencils to a key ring. They can be removed easily for use.

Visit CreateMixedMedia.com/Mixed-Media-Portraits for FREE bonus materials.

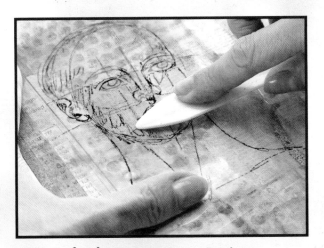
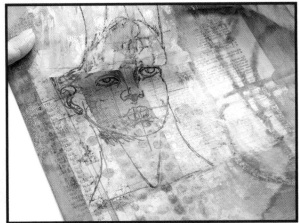

# 4 Transfer the Transparency Design

Trim the inkjet transparency of your sketch to create a ½-inch (13mm) border around the design. Use a 1-inch (25mm) flat to apply a thick, even layer of Mixed Media Adhesive or gel medium to the substrate where you want to transfer your sketch. (You can also use hand sanitizer in place of the medium.) Lay the transparency ink side down in the medium and burnish with a bone folder tool or the back of a spoon to transfer the design. Gently lift one corner to check on your progress and remove the transparency when completely transferred. Let dry thoroughly.

## TRICKY TRANSFERS

Use inkjet transparencies that are *not* waterproof, multipurpose or quick dry. I like 3M brand, but there are many brands available. Shop online for the best selection. If one brand doesn't work for you, try another.

Transfers are always a bit iffy. Printer inks vary, humidity affects the transfer, and it takes trial and error to find the perfect amount of medium and burnishing.

Here are some tips to make it go more smoothly: It's best to use a freshly printed inkjet transparency. If it's been sitting around for a while, the image won't transfer as well. If the transparency doesn't work the way you want it to, clean the background with a baby wipe, then dry the background and start with a fresh transparency. If you have a transfer method you like, stick with it.

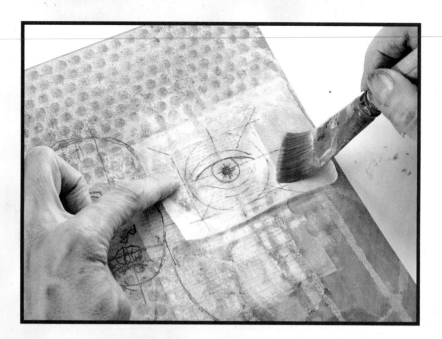

## 5 Add More Collage Elements

Create additional collage elements by tracing a stencil design or drawing directly onto dry wax deli paper with a permanent pen. Adhere the collage elements with Mixed Media Adhesive or gel medium, applying the adhesive to the back of the elements, to the substrate and then over the applied elements with a 1-inch (25mm) flat.

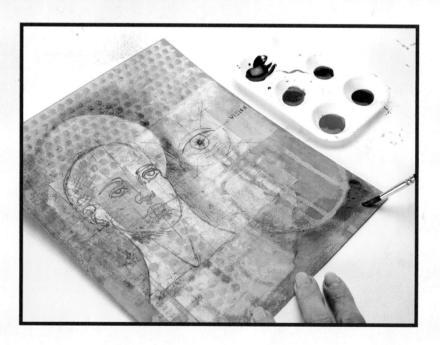

## 6 Add Acrylic Paint

Add Fluid Matte Sheer Acrylics or very diluted acrylic paint in colors similar to the inks used in Step 3. (I'm using Mustard Seed, Rusted, Turquoise and Rain.) Use a no. 8 round to drip elements around in the background and outside of the face. Begin to paint the face with the same colors.

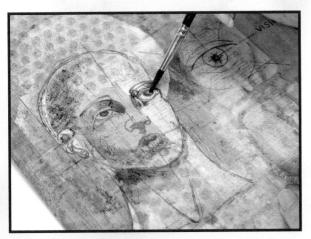

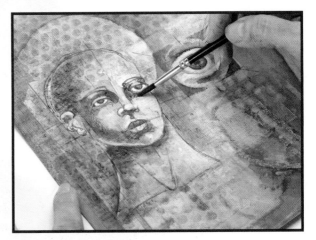

## 7 Add the Shadows

Use Big Brush pens in Gray and White to add shadows and highlights to the face. Starting with the Gray, color a small amount on part of the face. Activate and move the ink with a wet no. 8 round to shade. Apply Gray to the back side of the head, around the eyes and eye sockets, under the nose, the upper lip, under the lower lip and under the chin. Let dry.

## 8 Add the Highlights

Next apply White to the highlight areas, including the brow bone, a little on the middle of the forehead, down the nose, on the ball of the nose and the nostrils, the whites of the eyes, the cheekbones, the lower lip, the chin and the jaw. Let dry. Then go over the face with a little bit of the paint from the background (I'm using Mustard Seed), adding a very sheer layer of paint over the shaded areas with a no. 8 round.

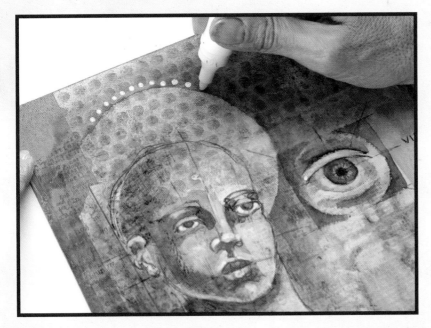

## 9 Embellish the Background

Use the White, Gray and Black pens to add design elements and journaling to the background as desired.

Listen to your inner voice, it will guide you on your journey in life, and lead you to your own authenticity

**Voice**

When you close your eyes you can truly see your artistic vision as it's intended fully

**Vision**

Each step you take in your artistic journey will lead you further down the path of your dreams

**Direction**

Listen to what the world around you is telling you. read what you hear

**Listen**

We often see so much that it's hard to allow our own artistic voice to be on the blurred once in a while

**See**

When you hear your artistic voice pay attention to it and allow it to unfold before you

**Hear**

# BLOCK HEADS

Artist trading blocks are much like ATCs (artist trading cards) in theory but with a unique 3-D approach. These little cubes allow for artwork on all sides, including inside the box. Using the Sizzix die to cut the boxes allows you to work on a wonderful assortment of substrates, but you can also use any type of cube such as one made from papier mâché or wood. For this project we'll pull apart our sketches and focus on the features of the face with an art journal style. It's art journaling cubed!

## MATERIALS

**Surface**
   artist trading block cut from mat board (pattern on previous page) or another block form

**Inktense Blocks**
   blue, brown, gold, orange, red, white

**Brushes**
   1-inch (25mm) flat
   water-reservoir brush or waterbrush

**Other Supplies**
   circle punch tool or scissors, copies of sketches, journaling pens, Mixed Media Adhesive or gel medium

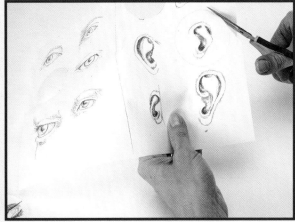

**1 Cut Facial Feature Circles**
Punch out or trace and cut out circles of various parts of the face from copies of your sketches. Cut two eyes, two ears, one nose and one mouth.

## 2 Adhere the Cutouts to the Cube

Adhere the cutout face parts to the mat board with Mixed Media Adhesive or gel medium. Use a 1-inch (25mm) flat to apply the adhesive to the back of the cutout, to the board and then over the top of the applied cutout. Be sure to coat the entire surface of the mat board with adhesive and let dry.

One of the images has to be upside down.

### ABOUT INKTENSE BLOCKS

Inktense are water-soluble ink blocks that can be used wet or dry and are available in blocks or pencils. When activated with water, they produce vibrant colors that become permanent once dry. They can be dipped in water and colored onto a substrate, applied to wet paper for intense color or used as pans of paint much like watercolors.

## 3 Paint Around the Features

Touch a waterbrush directly to the Inktense blocks and lift color, using the tray as your palette. Paint around the outside edges of the feature cutouts. Paint gold around half of each circle, letting it puddle out like watercolor. Paint a mixture of orange and gold (mix the color right on top of the gold) on the other side of each circle edge. Note: On the upside-down circle, apply the colors to the opposite sides. Let dry.

Visit CreateMixedMedia.com/Mixed-Media-Portraits for FREE bonus materials.

## 4 Shade the Facial Features

Begin shading the face parts inside the adhered cutouts with Inktense blocks. Mix brown and white to create a skin tone, and begin filling in shaded areas of the face parts.

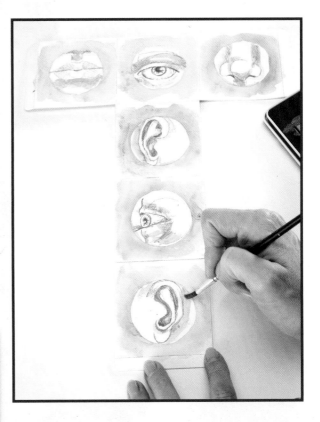

### PERMANENT COLOR

Once Inktense colors are dry, the color is permanent, so you can layer colors without lifting. You could use watercolors for this project, but they are not permanent and may lift.

## 5 Continue Painting the Background and Features

Continue layering colors around and on the face details. Add blue to the eyes, and then take it around the outside edge of the blocks. Mix red and white to apply to the lips. Add some pops of bright yellow or bright blue around the circle cutout. Continue layering colors as desired. Let dry.

## 6 Add Journaling and Details

Use journaling pens to add details, words and journaling around the cutout shapes. You can even add notes to the cube's inside surfaces. I made notes about the facial features and senses.

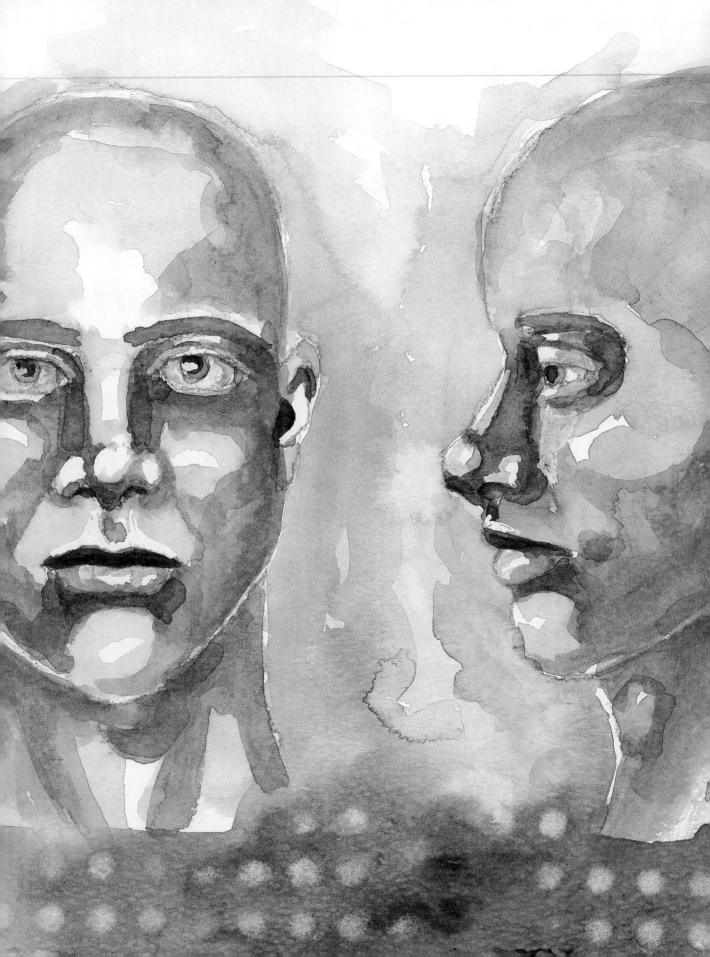

# COMPLEMENTARY COMPLEXION

Working with complementary colors is the extreme in color play. The combinations of color complements are dynamic as they play up each other's intensity, and, contrary to what you might think, they lend a soothing, balanced air to your work. By blending these colors together, they become more neutral and are perfect for creating portraits with depth.

## MATERIALS

**Surface**
Strathmore inkjet watercolor paper

**Watercolors**
complementary colors of your choice

**Brushes**
no. 8 round

**Other Supplies**
baby wipes, Incredible Nib or no. 6 round, liquid frisket or clear wax crayon, liquid frisket remover tool (optional), scanner/printer or lightbox, stencil

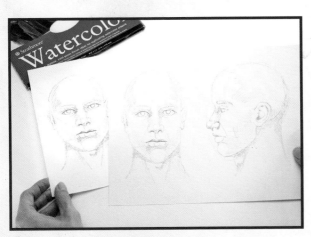

## 1 Print or Trace a Sketch

Print a saved sketch onto Strathmore inkjet watercolor paper, or you can trace your sketch over a lightbox.

### ABOUT THE INCREDIBLE NIB

The Incredible Nib wicks up the frisket and allows you to apply it like a marker. If you use a brush, be sure to wash it thoroughly after use. The frisket ensures that you will have white whites in your final painting.

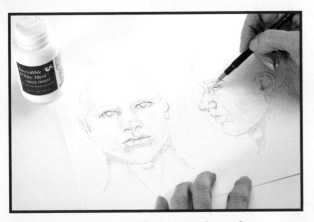

## 2 Preserve the Highlights With Frisket

Use an Incredible Nib tool or a no. 6 round to apply liquid frisket (or use a clear wax crayon) to highlight areas on the face, including the upper eyelids, the whites of the eyes, the bridge of the nose, ball of the nose, nostrils, the philtrum area, lower lip and the outer fold of the ears. Let air dry.

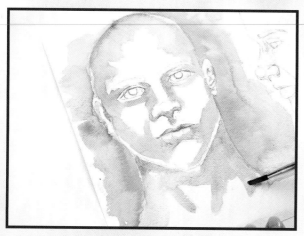

## 3 Paint the Background and Shade the Face

Choose a color combination from the Complementary Color Slides in Chapter 4. Apply the darker/cooler of your chosen colors (I used Phthalo Turquoise) to the left of the face with a very wet no. 8 round. Then apply the lighter/warmer color (I used New Gamboge) to the right side.

Add the lighter/warmer color to the shaded areas of the face with a very wet no. 8 round. Start around the outside edge of the forehead, painting in toward the temple a bit. Then paint around the eye socket areas, down the sides of the nose, underneath the nose, the upper lip, the lower lip, under the lip, the cheekbones above the jawline, under the chin in the neck area and the inner ears. Let air dry.

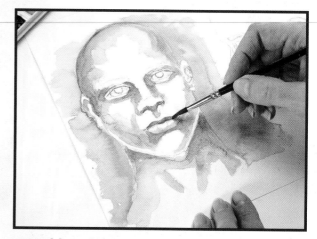

## 4 Add Dark Accents With the Warmer Color

Using a darker concentration of the lighter/warmer color and a no. 8 round, add darker touches to the edges of all the areas you just shaded. Let dry.

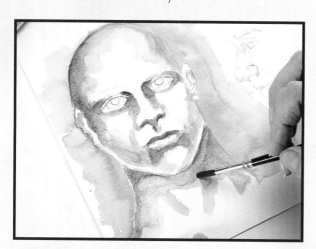

## 5 Paint the Darkest Shadows

Use the darker/cooler color to create the darkest shadows. With a very wet no. 8 round, apply the color to the left side of the top of the head in the temple area, a little into the outer corners of the eye sockets, the nostril area, a little in the philtrum area, the midline of the lip, under the lip and under the chin.

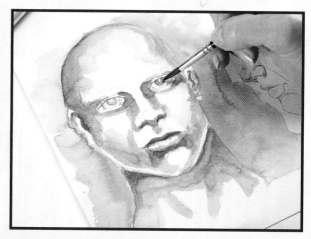

## 6 Add Dark Accents With the Cooler Color

Use a no. 8 round to add a darker concentration of the darker/cooler color to the eyes, to the inner ear folds, the middle of the lip and under the chin. Let dry.

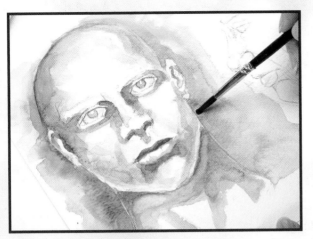

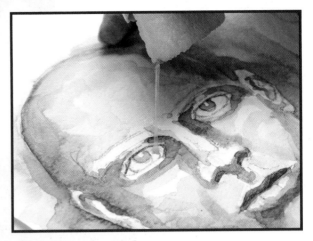

## 7 Continue Layering the Face and Background

Keep layering colors with a no. 8 round, letting them dry, then adding more on top to create the tonal values of the skin. Let dry.

Build up layers in the background as well. You can mix the complements together to create additional colors in the background. Let dry.

## 8 Remove the Frisket

Remove the liquid frisket by gently rubbing and pulling with a remover tool or with your fingers. (If you used wax crayon, you won't be able to remove it, so it will remain part of the piece.) Add additional watercolor to help blend the white areas into the surroundings as needed. Let dry.

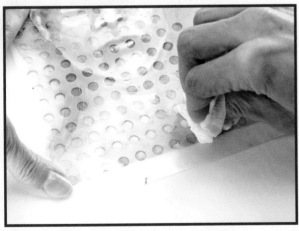

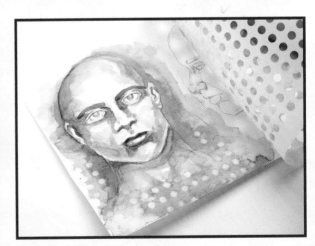

## 9 Add Stencil Designs to the Background

Lay a stencil on the background and use a baby wipe to lift some of the paint to reveal the design.

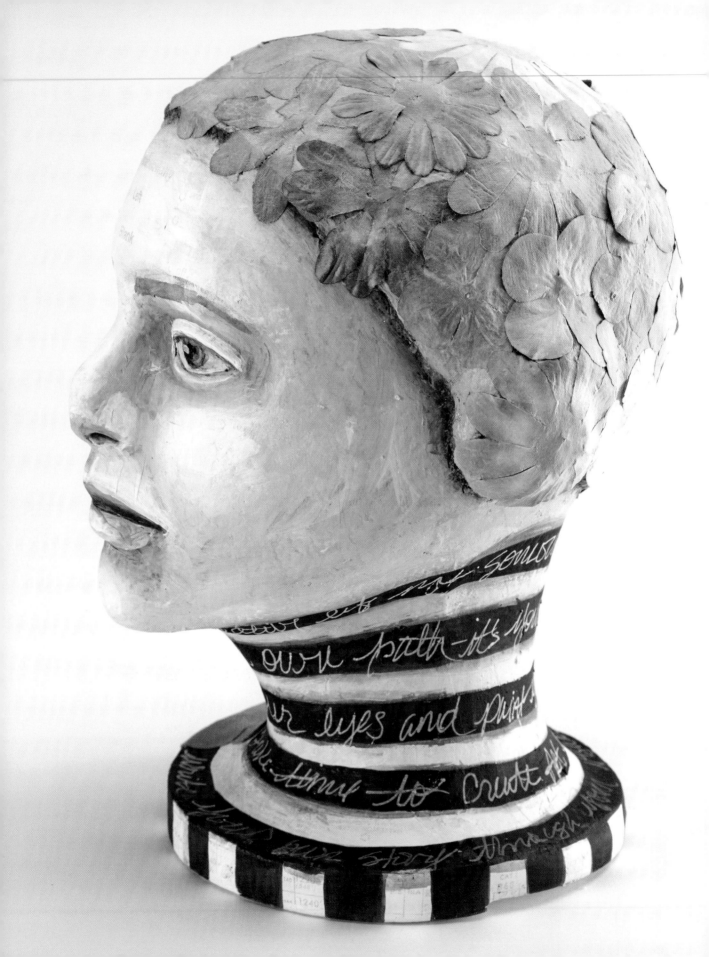

PROJECT 14
# BUSTING OUT

Creating a 3-D portrait bust takes portraits to a whole new level. This bust is like a dimensional self-portrait journal page, incorporating collage, journaling, sculpting and painting. We will bring a Styrofoam wig form to life and create a work that is reflective of who we are at this moment in time, what we stand for, and where we want to go. Layers of under-journaling represent the layers that form us. Most of us can put on a pretty good outward face, but it's what's underneath that matters most and defines who we are. We'll dig down to find out what's behind the face the world sees.

## MATERIALS

**Surface**
Styrofoam wig form

**Conté Pencils**
Sanguine or your choice of colors

**Inktense Blocks**
blue

**Faber-Castell Big Brush Pen**
Warm Gray

**Brushes**
1-inch (25mm) flat
nos. 6, 8 round

**Other Supplies**
1-gallon (3.8l) plastic bag, baby wipes, CelluClay or other paper clay, collage material, gesso, Mixed Media Adhesive or gel medium, paper flowers or embellishments, paper towels, permanent black pen, sandpaper or small sanding block, Stabilo All pencil or other water-soluble pencil

**1 Sand off the Mold Line**
Using a little piece of sandpaper or a sanding block, sand off the mold line around the sides and top of the bust.

**2 Apply a Gesso Layer**
Prep the surface by applying a layer of gesso with a 1-inch (25mm) flat, covering the entire bust.

## FACE ADJUSTMENTS

You can also use CelluClay to alter the wig form. Adjust the nose, chin, cheekbones and so on before the gesso stage (Step 2), then gesso over the clay.

### 3 Papier Mâché the Bust

Tear small pieces of collage material (newspaper, tissue, other thin papers with text), and apply them to the entire head except for the hair area. Using a 1-inch (25mm) flat, apply Mixed Media Adhesive or gel medium to the back of the papers, to the surface of the head and then over the papers after they are applied. Let air dry. Caution: do not use a heat tool on Styrofoam.

### 4 Apply a Gesso Wash

If your papier mâchéd scraps look particularly busy, use a 1-inch (25mm) flat to apply a wash of gesso (1 part gesso to 4 parts water) to obscure some of the text. You should be able to see through the gesso. Let air dry.

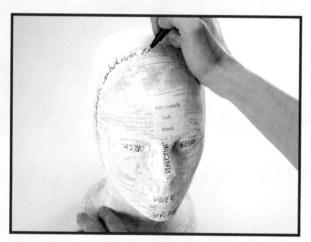

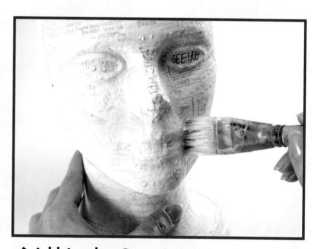

### 5 Add the Under-journaling

Use a permanent black pen to write or journal on the bust. I call this "under-journaling" as most of what you write won't actually be visible when the project is finished. This is a very free form of writing. You can literally empty your thoughts onto the artwork. Don't worry about penmanship—just open up your mind and allow your hand to unload your thoughts.

### 6 Add Another Gesso Layer

Use a 1-inch (25mm) flat to add another wash of gesso (1 part gesso to 4 parts water) over the whole head including the scalp area to help obscure the writing. Add more gesso if you want a more opaque surface or less if you want more of the writing to show through. Let air dry.

Visit CreateMixedMedia.com/Mixed-Media-Portraits for FREE bonus materials.

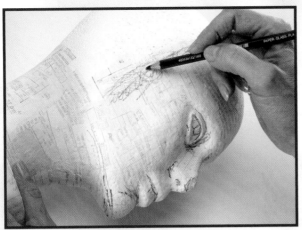

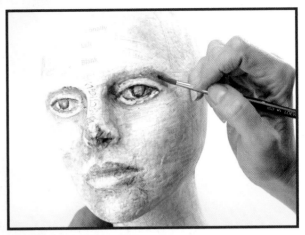

## 7 Shade the Face

Use a water-soluble pencil such as a Stabilo All pencil to color shaded areas of the face, including the hairline, the eye sockets, lash lines, pupils, sides of the nose, under the nose, the upper lip, underneath the bottom lip and under the chin. Apply water with a no. 8 round to activate the pencil.

## 8 Blend the Shading With Gesso

Begin painting the face with gesso and a wet no. 8 round. The paint will blend with the water-soluble pencil to create tonal value on the face. Vary the intensity by increasing or decreasing the amount of gesso. Repeat pencil applications as needed to deepen the shading.

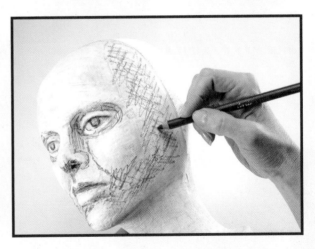

## 9 Color the Shaded Areas and Blend

Use a Sanguine Conté pencil to add color to all of the shaded areas. (You can use any color of Conté to create the skin tone of your choice.) Apply the Conté in crosshatching motions, then blend with a wash of gesso and a wet no. 8 round. Vary the amount of gesso to create different skin tones. You can also use a baby wipe to lighten and blend the color. Add more pencil to redefine the dark areas as needed. Let air dry.

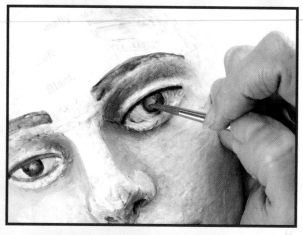

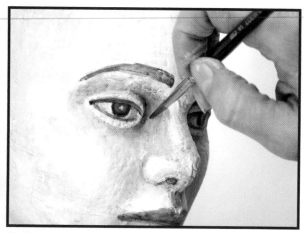

## 10 Add Dark Accents and Blend

Use a Warm Gray Big Brush pen to color really dark areas. Apply the pen to one small area at a time and blend out with a wet no. 6 round before it dries. Darken the eyebrows, inner corners of the eyes, the pupils, the irises, the nostrils and the midline of the lips. Make sure the paint is dry before adding more pen.

## 11 Add Color

Apply Inktense Artists Blocks for more color. Touch a wet no. 8 round to the block to lift color, and apply Iris Blue to the hairline, around the eyes in the deep shadow areas, underneath the chin and to the irises (if you want blue eyes). Also use the blue to lightly shadow under the upper eyelids on the whites of the eyes. Let air dry. If the colors look too mottled, apply a wash of gesso with a 1-inch (25mm) flat to help blend the colors and let dry.

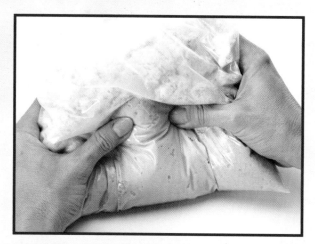

## 12 Papier Mâché Clay

Mix ½-lb. (227g) of CelluClay (or use other paper clay and mix according to directions on package) with 16 oz. (.47l) of water in a sealed 1-gallon (3.8l) bag. Massage the bag to mix the clay and water, adding more water if it seems too dry. The clay is ready once the water is completely incorporated.

## ART FOR HEALING

I taught this project as a workshop at an Art for Healing retreat. Many of the women had cancer and had lost their hair due to the treatment. Working on these bald Styrofoam heads was a way for them to express what they were experiencing in their battle against the disease. They created beautiful art, and many left their ladies bald. It helped them to see that they were beautiful. Hair did not make them beautiful, but rather the strength with which they fought did. I will never forget that experience and what it taught me about the importance of art, healing and self-acceptance.

Visit CreateMixedMedia.com/Mixed-Media-Portraits for FREE bonus materials.

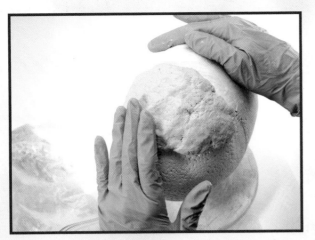
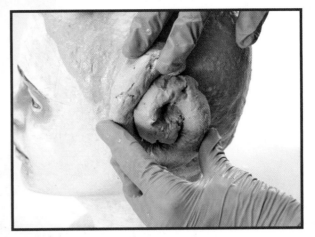

# 13 Form the Hair With Papier Mâché Clay

Place paper towels under the bust and keep warm water on hand to wet your hands as needed. Grab a handful of the clay and knead it in your hands. Flatten it in your hand and lay it over the head. Keep your hands wet and form it to the head (keep the clay bag closed while working). Wet the palm of your hand and smooth the bumps out of the clay as you go. (The clay is sandable once it's dry, so you will be able to smooth out any remaining irregularities.) Once you've covered the entire scalp with about a 1-inch (25mm) layer of clay, you can shape the hair as desired, creating buns, long hair, bangs and so on. (I made Princess Leia buns by rolling out two ropes of clay and coiling one over each ear, blending the edges into the scalp.) Let dry overnight.

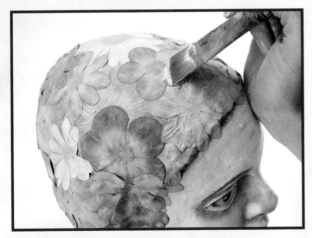

# 14 Embellish the Scalp and Neck

Add other elements such as flowers and buttons, using Mixed Media Adhesive or gel medium and a 1-inch (25mm) flat. Apply the adhesive to the back of the elements, to the scalp and then over the elements after they are positioned. Paint the hair as desired.

Journal on the neck area as desired with a black permanent pen.

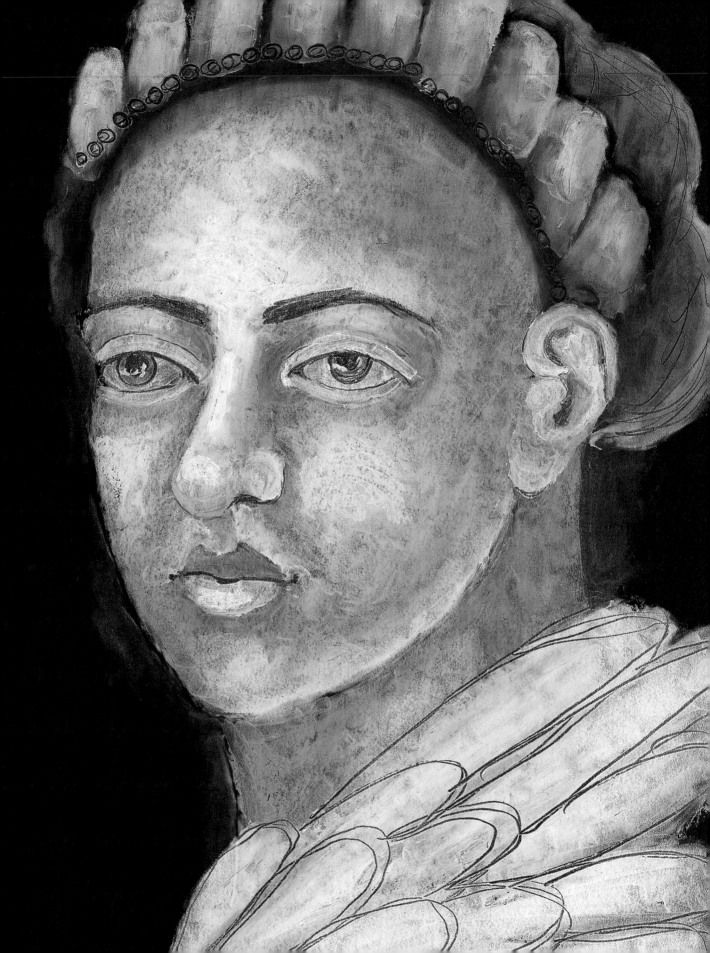

PROJECT 15
# SCRATCHING MY HEAD

For the final project we'll go a little old school and dig out those oil pastels and use a very old method called "sgrafitto" to scratch design into the applied pastel. You may have avoided using oil pastels because you think they're messy and hard to use, but this project will show a way to use them that leaves your hands clean and your art beautiful!

## MATERIALS

**Surface**
Strathmore Artagain black paper

**Oil Pastels**
Black, Blue-Gray, Flesh Ochre, Burnt Sienna, Luminous Yellow, Violet Ochre, White, Yellow Ochre

**Other Supplies**
ballpoint pen or stylus, sgraffito tool or other scratching tool, Wipe Out tool or other blending tool

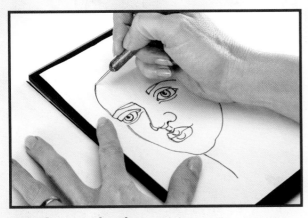

## 1 Emboss a Sketch
Place a copy of a sketch on top of a piece of Artagain paper or thick black pastel paper. Use a stylus or ballpoint pen to trace all the lines. This will leave embossed marks on the black paper.

## ABOUT OIL PASTELS

Oil pastels are pigments mixed with a binder to create a soft, easily blended, slightly greasy stick. The binder is made of mineral oils and waxes. Because oil pastels include mineral oil, they never really dry.

There are many different brands from high-end artist quality to very inexpensive school grade, and each will behave differently. I prefer Sennelier for this demo because they are so smooth and creamy. They're expensive, but you can buy them individually, which makes them a bit more affordable. But use what you have—there's no need to buy new ones.

## 2 Apply Flesh Ochre to Reveal the Lines
Color over all of the embossed marks with a Flesh Ochre oil pastel. You should be able to clearly see the embossed lines.

## 3 Add the Highlights

Add White oil pastel to highlight areas, including the middle of the forehead, on the brow bones, the bridge of the nose, the ball of the nose and nostril, each upper eyelid, a little highlight underneath the eyebrows, the whites of the eyes, lower eyelids, cheekbones, above the upper lip, on the lower lip, the ball of the chin, the jawline, the outer folds of the ear and the side of the neck.

## 4 Establish the Shaded Areas

Add Yellow Ochre directly to the shaded areas, including the outside edges of the forehead, the eye socket area, the side of the nose, under the nose, under the lower lip, along the jawline (next to the white highlight) and under the chin on the neck.

## 5 Add Violet Ochre Shadow Accents

Use Violet Ochre to deepen the shade on the inside corners of the eyes, under the nose, under the lower lip, underneath the jawline and to the inner folds of the ear.

## 6 Add Blue-Gray Shadow Accents

Add touches of Blue-Gray to the darkest areas, including the innermost corners of the eyes, under the bottom lip and in the inner ear.

Visit CreateMixedMedia.com/Mixed-Media-Portraits for FREE bonus materials.

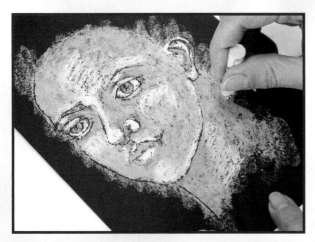

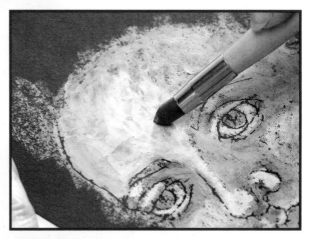

## 7 Unite the Colors With Luminous Yellow

Use Luminous Yellow to pull all of the colors together, applying it to all areas except for the white highlights, blending as you color.

## 8 Blend the Colors

Use the Wipe Out tool to blend, using the wider tip for the larger areas and the smaller tip for the intricate areas around the eyes, ear and lips. Reestablish white highlights as needed.

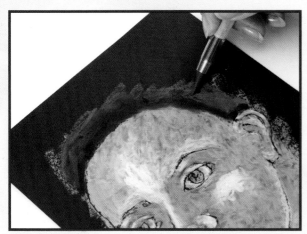

## 9 Add the Hair and Clothing Areas

Add Black and Burnt Sienna to the hairline and blend with the Wipe Out tool. Add decorative elements to the hair as desired. Color White below the neck area, and blend with the Wipe Out tool to create a base to scratch into for the clothing.

## 10 Scratch the Hair, Clothing and Details

Use a sgraffito tool to gently scratch the hair, clothing and additional details into the work. Scratch out black areas for the pupils of the eyes, the nostril and to reestablish eye details as needed.

# ARTISTS SHARE: TECHNIQUES

## WHAT ARE SOME TYPICAL QUESTIONS STUDENTS OR VIEWERS ASK ABOUT YOUR TECHNIQUES?

"I am often asked about whether my faces are painted or collaged—they are both. Some completely painted, others collaged and painted over with some of the features changed along the way. I am also often asked about the color combinations I use in my work and how to achieve bold, vibrant paintings."

—ANDREA MATUS DEMENG

"I think I get more questions about the subject and story of the piece than about actual techniques. A favorite question is, of course, 'How long did it take you to do that?' I give artist James Whistler's answer, 'My whole life.' People ask the most technique questions about mixed-media work such as 'What glue do you use?' 'What kind of paint did you use?' 'How did you make her look so alive?' If the portrait is done in encaustic, then I get lots of questions about what encaustic is and what the encaustic process entails."

—SERENA BARTON

**Seadusa**
by Andrea Matus deMeng
acrylic, oil and collage on canvas
45" × 31" (114cm × 79cm)

Visit CreateMixedMedia.com/Mixed-Media-Portraits for FREE bonus materials.

**Man in the Moon**
by Michael deMeng
mixed media on wood
14" × 12" × 3" (36cm × 30cm × 8cm)

"The one I get the most is 'How does your brain come up with this stuff?' You must understand that (A) I make things out of discarded things, and (B) my things are fairly demented looking when I get done."
—MICHAEL DEMENG

"I am often asked what inspires my artwork. I'm inspired by everyone and everything that enters my path … the texture in a rusted chain-link fence, the beautiful shades of autumn leaves, bold colors of a vintage Hawaiian muumuu, the animals and nature I see during my daily walks, typography, vintage crafts or a conversation. I am open to taking bits and pieces of everyday life and incorporating them into my sketchbook, art journal or mixed-media creations."
—TRACI BAUTISTA

"I am often asked how I make something transparent. My favorite technique when using acrylic paint is to mix acrylic medium or glazing liquid with a small amount of white. Test the transparency of the mixture first on a piece of scrap. The more white, the less transparency. Brush the mixture over the area that you want to look transparent. After the mixture is dry, you may brush over it with another mix using a color instead of white. Experimenting freely with this technique is the best teacher. There are infinite possibilities for adding layer upon layer of transparency at any stage in the process to create a visually rich surface."

—CINDY SILVERSTEIN

**She Wants**
by Dina Wakley
acrylic and Stabilo pencil on journal paper
11½" × 9" (29cm × 23cm)

"Many people ask me what art materials I use to draw my faces, especially, 'What pencil is that?' The pencil I use in my journal is the Stabilo All pencil. It is made to draw on paper, glass, plastic and metal. Since acrylic paint is plastic, the pencil works well and you can get a very dark line. It is water-soluble, too, so you can pull out shading or even wipe your drawing off altogether if you don't like it. I sometimes call it the "magic pencil" because it makes you look better than you are when you draw.

"I also get asked a lot about white space. White space is an integral part of my art. White space is sometimes called negative space, and it is simply the area where your focal point is not. And white space does not need to be white. I have learned, though, that I like some space that is actually white in my work. By leaving some areas open, I can get away with more (i.e., more colors, more layers), because the eye has a place to rest. The white also makes the colors I use look more vivid."

—DINA WAKLEY

"A question I often get asked is how to get over the fear of the blank page. I tackle it differently at times. Sometimes I simply squirt on some folk art paint onto a piece of cardstock and begin to scrape on the paint with a discarded credit card. Other times I might start doodling and let the doodles take me to where they want to go. If I listen very quietly and intently, I will hear my muse and her prompting … it might be to begin drawing a face … or it might be to begin with a scrape-painted background. It's like I stop the process and ask internally, 'Now what? What's next?' If I'm patient enough, I will hear my muse tell me what to do next. It's always one grand adventure. I never know from one moment to the next what will happen. It's so exciting."

—VIOLETTE CLARK

"I love watching people when they first see my work 'in the flesh' because so many of them stroke the surface. There must be something invitingly tactile about it, making matte varnish a must! People lament that they can't draw, and I always disagree. Of course they can draw—anyone can draw. I suppose they mean they can't draw like the brilliant artist of their dreams, but can anyone if they don't work at it? Maybe it's because drawing is one of the first things we learn as children. And if we are not declared an art genius by age seven, we let it fall away as an impossibility. Drawing is so good for you because it engages so many parts of the brain from memory to imagination and hand-eye coordination. I believe drawing faces can serve the same purpose as dreaming … they can free you."

—JANE DAVENPORT

**Do You Want My Presence**
by Jane Davenport
acrylic, ink and colored pencil on 140-lb.
(300gsm) hot-pressed paper
13" × 10" (33cm × 25cm)

"Some people ask me, 'How do you think things like that up?' I don't think my way into or through a painting; it's more about intuition and feeling. As I paint, things arise. When something arises that I feel connected to, then I continue in that direction.

"I am also asked how frequently I paint. It varies. I go through spells where I'm painting many hours a day most days (especially in the winter when it's rainy here in the Pacific Northwest), but when it's sunny and warm, you'll find me working outside in the garden. I go with the ebb and flow and follow my passion."

—KATIE KENDRICK

"I am frequently asked, 'Where do you get your ideas?' My ideas are a rich brew of many experiences. I love to look at people's faces and am a student of facial features and expressions. I love to collect color combinations that inspire me from the natural and material world. I rarely draw from a reference photo. I often play some favorite music, relax and see what comes out of the end of my pencil."

—KATE THOMPSON

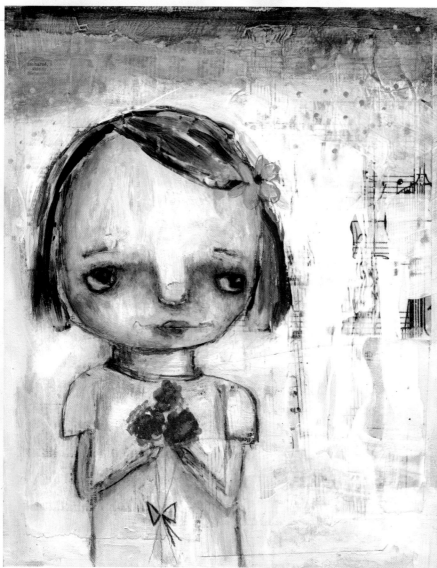

"A question that I get asked frequently is how did I come up with my style. My answer is always, 'All by mistake.' While I was painting a face one day, I had a piece of bleeding blue tissue paper that was covering one side of the face. I kept trying to paint over it, but the tissue paper has ink in it that tends to keep showing through, no matter how much you try to paint over it. Frustrated with the process, I set it aside and came back to it the next day. When I revisited it that next morning, I realized that the blue color really served to help mold and make the side of the face go back in space. Since cool colors recede, it seemed to work! It helped the face seem to be not as flat and more dimensional. I am so thankful for that happy accident and 'mistake' because now I paint blues and greens on the sides of the face on purpose."

—MINDY LACEFIELD

**Heidi**
by Mindy Lacefield
acrylic, mixed media on board
10" × 8" (25cm × 20cm)

"I am often asked how I am able to convey such feelings with the portraits I make. This question is very difficult to answer. Every person who views art is going to see it and feel it differently. I do put quite a lot of myself, my moods and current events in my life into my work. Maybe people pick up on that and can relate? I tend to paint mostly women, so I think I convey more regarding women's issues. I use facial expressions, body language and hand gestures to express what might be going on with the subject. Sometimes it's the title that says just as much as the art itself. In fact, sometimes I know right away what the title will be and will paint to that. Other times, I will be finished with the painting and have to look at it for some time prior to naming it."

—JANE SPAKOWSKY

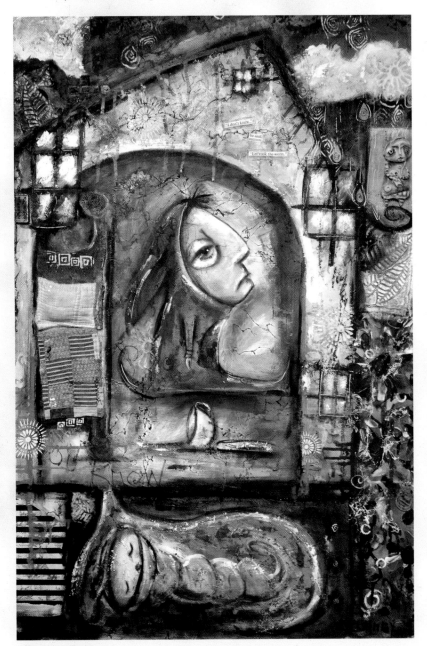

**Albert in His House**
by Sunny Carvalho
acrylic, fabric, mixed media on birch panel
36" x 24" (91cm x 61cm)

"Sometimes people ask, 'How long does it take to create?' The time it takes to create can range from as short as a few minutes to do a quick sketch all the way to weeks to work on a piece that is still in need of just the right element. When I'm asked, 'Where do you find time to do this?' I respond that I *make* the time, because engaging in the creative process is critical to my sense of well-being."

—CYNTHIA STROO

"I'd have to say, 'What colors do you use for skin tones?' has been asked most frequently. Typically my color palette tends to be cool, even when it comes to skin tones. I use Titanium White, Alizarin Crimson and Quinacridone/Nickel Azo Gold."

—MISTY MAWN

"Most of the questions that I get are more about imagination and inspiration than specific techniques, although I do often get questions about certain effects such as, 'How did you get the lightness in this area?' I also get a lot of questions about how I paint the eyes of my characters."

—SUNNY CARVALHO

# TEMPLATES

You can draw your color wheels freehand, or feel free to trace, copy or enlarge these templates for your own personal use. You can also download and print them from CreateMixedMedia.com/Mixed-Media-Portraits.

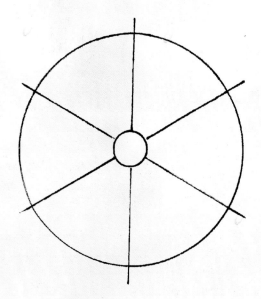

### Neutrals Color Wheel
Use this template for the tonal values color wheels and in Project 6.

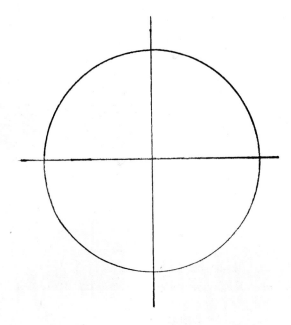

### Hue, Tint, Tone and Shade Color Wheel
Use this template for the color wheels in Projects 4 and 9.

### Complementary Color Wheel
Use this template to create a complementary color wheel to make grayed colors and no-mud neutrals.

# RESOURCES

## BOOKS
*Drawing the Human Head* by Burne Hogarth
*Drawing: The Head* by Nathan Rohlander
*Color Mixing Recipes for Portraits* by William F. Powell

## SUPPLIES
Pam Carriker Signature Mixed Media Products:
jerrysartarama.com
Matisse Paints and Mediums: derivan.com.au
StencilGirl Products: stencilgirlproducts.com
PanPastels by Colorfin LLC: panpastel.com
Gelli Arts® Gelli Printing Plates: gelliarts.com
Sennelier Oil Pastels: sennelier-colors.com
Derwent Inktense Blocks: pencils.co.uk
Thermofax Machines Welsh Products, Inc:
welshproducts.com
Custom Thermofax Screens:
Lynn Krawczyk, smudgedtextilesstudio.com
Speedball Silkscreen Supplies: speedballart.com
Polyester Print Plate Pronto-Plate 5000: dickblick.com
Guerrilla Carton Plein Air Panels: guerrillapainter.com
Yupo Paper: yupousa.com
Alcohol Inks: rangerink.com
Fantastix: tsukineko.com
Inkjet Watercolor Paper and Other Papers:
strathmoreartist.com
Enkaustikos: encausticpaints.com
Caran d'Ache Neocolor II and Gouache:
carandache.com
Heavy-Duty Paper Bags: unline.com

**Medium and Gesso**
Here are the mediums and gesso I use most frequently, including my signature Mixed Media Adhesive.

**Acrylic Inks and Fluid Matte Sheer Acrylics**
Here's my signature line of Acrylic Inks and Fluid Matte Sheer Acrylics from Derivan Matisse.

## METRIC CONVERSION CHART

| To convert | to | multiply by |
|---|---|---|
| Inches | Centimeters | 2.54 |
| Centimeters | Inches | 0.4 |
| Feet | Centimeters | 30.5 |
| Centimeters | Feet | 0.03 |
| Yards | Meters | 0.9 |
| Meters | Yards | 1.1 |

# ABOUT THE CONTRIBUTING ARTISTS

## SERENA BARTON

Serena Barton lives in Portland, Oregon, where she makes art, has a part-time counseling practice, teaches art workshops and provides individual art coaching. She exhibits and sells her work in galleries and online. She teaches at national art retreats and other venues. With artist Leighanna Light, she offers an annual mini-retreat in Taos, New Mexico. Her articles have appeared in *Cloth Paper Scissors* magazine, *Somerset Apprentice* and *Studios* magazine. Her book *Wabi-Sabi Art Workshop: Mixed Media Techniques for Embracing Imperfection and Celebrating Happy Accidents* was published in 2013 by North Light Books. She is currently working on a book about oil and cold wax painting to be published by North Light in 2015.

## TRACI BAUTISTA

Once a corporate go-getter in Silicon Valley, Traci Bautista left a successful marketing and graphic design career in 2001 to pursue her passion for art and share her love of creativity with people worldwide. Focusing her artistic energy into treiC designs, Traci has become an accomplished mixed-media artist, creative entrepreneur and instructor and is the author of *Collage Unleashed*, *Doodles Unleashed* and *Printingmaking Unleashed*. She has been a regular guest on DIY/HGTV's *Craft Lab*, and her art has been featured in more than fifteen art and mixed-media books, numerous blogs and more than forty magazines.

Traci contributes her success as an artist to her past experiences and innate drive to explore and create without boundaries. She has taught workshops in handmade books, art journaling, creative business and surface design. Traci has been a close collaborator with iLoveToCreate throughout the years,

developing successful product lines such as Collage Pauge Instant Decoupage. She designs digital art journaling products and e-courses for her own digital shop, treiCdesignsdigitals.com. Her latest venture is the opening of {studio 323*7}, her art studio and boutique in Danville, California. To follow her creative musings, visit her at treicdesigns.com.

## SUNNY CARVALHO

Sunny Carvalho is a mixed-media artist living in Alabama amid the chaos of too many art supplies. Focusing on hand-sculpted ceramic dolls and pendants and mixed-media paintings, her quirky characters have found their way into many of the mixed-media magazines. She is an instructor with Artfest (Seattle), Art is You (Petaluma and Benecia, California, and Nashville and Memphis, Tennessee), and Art Unraveled (Phoenix), as well as various individual studios. According to her husband, she lives in a world where everything is happy and squirrels iron her pants.

Contact Sunny at sunnycdolls@aol.com or visit her at facebook.com/sunny.carvalho.5 or sunnycarvalho.blogspot.com.

## VIOLETTE CLARK

Violette is an artist, author and an idea factory. She has a passion for art journaling and helping women nurture their creativity. As a free spirit, she shares her funky outside-the-box life with her blog readers and Facebook friends. Her art has been featured in a number of publications as well as in her own book, *Journal Bliss*. Violette teaches workshops and gives Mojo Sessions to women who need to get their mojo going. You

can find her hugging trees or happily creating in her purple magic cottage in White Rock, British Columbia. Visit her at violette.ca and purplejuice.ca.

## JANE DAVENPORT

Jane "Danger" Davenport is an internationally recognized artist and prize-winning author. Faces feature strongly in Jane's whimsical work, often with somewhat wistful or melancholy expressions and surrounded by interacting color and nature. Her online art school is home to thousands of creatives from all around the world, and her *Whimsical Face* DVD has been hugely popular. Through her online art school, publications and Escape Artist Retreats, Jane has enabled tens of thousands of creative people from around the world to embrace their innate artistic selves and accelerate their own progression. She is based at "The Nest" overlooking Byron Bay, Australia, and has koalas in her garden. Visit her at janedavenport.com.

## ANDREA MATUS DEMENG

Andrea Matus deMeng is a visual artist living in Vancouver, British Columbia, who exhibits as well as teaches her unique combination of painting, collage and sculpture.

As an art instructor, Andrea conducts workshops from coast to coast across North America and is including workshops in Europe and Australia in the upcoming months.

Her most recent project involves co-authoring a book with her artist-husband Michael deMeng. The book, titled *The Art Abandonment Project*, was released in spring 2014. Visit her at andreamatus.com.

## MICHAEL DEMENG

Michael deMeng is an assemblage artist from Vancouver, British Columbia, who exhibits throughout the United States. As an educator, he has been actively involved with VSA Montana, providing art education and encouraging participation in the arts to people with disabilities. Through these activities, as well as his artwork, Michael fosters community awareness and offers creative methods to explore the human experience.

In his art, he addresses issues of transformation. Discarded materials find new and unexpected uses in his work; they are reassembled and conjoined with unlikely components, a form of rebirth from the ashes into new life and new meaning.

These assemblages are metaphors for the evolutions and revolutions of existence: from life to death to rebirth, from new to old to renewed, from construction to destruction to reconstruction. These forms are examinations of the world in perpetual flux, where meaning and function are ever changing. Visit him at michaeldemeng.com.

## KATIE KENDRICK

Katie Kendrick lives along the banks of the Tahuya River in western Washington. The peaceful beauty of her natural surroundings is a constant source of inspiration and nourishment for her creative spirit. She finds art making to be one of the most powerful ways to connect with her innermost essence, while at the same time discovering her authentic voice. She enjoys the experimental and intuitive layers of creating, where she can explore inner and outer worlds simultaneously. She has a passion for sharing her love of creating with others and teaches mixed-media workshops across the United States and

internationally. Her first book, *Layered Impressions: A Poetic Approach to Mixed-Media Painting* was released in 2012.

## MINDY LACEFIELD

Mindy Lacefield is a mixed-media artist who draws inspiration from the nostalgia and rainy days of her childhood. Creating from the heart of a seven-year-old, Mindy cherishes the tactile process of painting. As the layers and colors evolve, decisions are made in the moment. Mistakes are applauded and accidents cherished. Only the process of making mistakes fosters growth. Surrendering to the outcome of the finished work allows her to be one with the process.

Mindy is a full-time artist living in central Arkansas with her husband and two poodles, Merlin and Sammy. She teaches around the country and online at timssally.ning.com. You can read more about her journey through her blog at timssally.com.

## MISTY MAWN

Misty Mawn is a full-time artist, mother and workshop instructor. She spends every single day possible creating, playing, exploring, learning and constantly being inspired and intrigued by everything around her. Her passion to create continues to bless her life with purposeful work and fulfilling adventures. When not in the studio, she can be found amusing and being amused by her two darling children, cooking up some creative concoction in the kitchen or strolling the back trails with her beloved camera in hand. She has been published in several mixed-media art books and magazines, and is the author and photographer of *Unfurling, a Mixed-Media Workshop*. She teaches mixed-media

art workshops internationally, locally and online. Visit her at mistymawn.typepad.com.

## CINDY SILVERSTEIN

Cindy Silverstein is a mixed-media painter. Working with layers of acrylic paint, ink and collage papers on canvas, she combines the power of positive words and phrases with her images of people, animals and the beauty of nature.

"I like to say that I paint beautiful thoughts. I want my paintings and words to inspire, uplift and empower people with the understanding that inside of them is an abundance of love and creativity that is available to help them manifest the life they want."

Cindy has illustrated for children's books, magazines, greeting cards and giftware companies. Her paintings and prints have sold in galleries and gift shops, and she has worked as a designer in the advertising industry. She was recently honored as a semifinalist in Lilla Rogers' Global Talent Search.

Cindy blogs about her artistic process at cindysilverstein.blogspot.com. You can also find her at facebook.com/CindySilverArt and etsy.com/shop/CindySilverstein.

## JANE SPAKOWSKY

Jane Spakowsky lives in Washington state. She grew up submerged in an artistic culture, and her father passed on his love of art and music to her. All her life she has been expressing herself through one form of creativity or another.

Some of her favorite things to make are mixed-media paintings and unique art dolls. She has a growing interest in Impressionism and enjoys many mediums. She especially finds pleasure in collecting what others might throw away and turning it into something beautiful. Jane enjoys sharing her tech-

niques by teaching workshops. She offers original paintings online and occasionally in galleries. Her artwork is collected both locally and worldwide.

## CYNTHIA STROO

Cynthia Stroo is a Seattle-based artist who combines her love of drawing, painting, photography and textiles with a sense of wonder about the world surrounding her.

She seeks the flow that creating art brings and the sense of joy that comes from bringing the invisible forth to the visible world. She loves to draw portraits without a reference and then discover who emerges from the paper.

A past career as a psychiatric RN informs her view of art as a strong tool that brings lessons and magic to the soul of both the creator and the viewer.

Creating art provides her with a language of expression and understanding of this big world.

## KATE THOMPSON

Kate Thompson's work as an artist using fabric and fiber to create abstract three-dimensional forms was her focus for many years. She started painting full time in 2009, and her current work combines the two disciplines. Using watercolors, acrylics, inks and pastels, she paints on substrates such as layered vintage linens, laces, plaster and wood. The portrait or figure is the focal point of her work, creating images that parallel her spiritual life.

Kate teaches online as well as studio classes. She is starting to travel around the United States, teaching at Random Arts in Saluda, North Carolina; Donna Downey Studio in Huntersville, North Carolina; Art and Soul in Portland, Oregon; Art is You in Nashville, Tennessee; as well as private workshops. Her passion is focused on the creative process, and she is as passionate about teaching as she is at creating art.

To learn more about Kate, visit her at: fracture dangelics.com, fracturedangelics.blogspot.com, facebook.com/katethompsonartist.

## DINA WAKLEY

Dina is a mixed-media artist and teacher. She loves everything about art: creating it, thinking about it, looking at it and teaching it. She lives in sunny Arizona with her husband and three boys. Her work has been published in many magazines and books.

Dina is passionate about teaching art. She teaches both in-person and online workshops. She is a docent at the Phoenix Art Museum, where she gives tours to school groups and gets kids excited about art.

In partnership with Ranger Ink, Dina designed a line of mixed-media art supplies that includes acrylic paints, mediums, brushes, rubber stamps and stencils. Look for the Dina Wakley Media Line by Ranger at a store near you or visit rangerink.com.

Dina loves hanging out with good friends, reading good books, cooking good food and traveling to good places. You can visit her at her website: dinawakley.com.

# INDEX

a content + ecommerce company

Other fine North Light Books are available from your favorite bookstore, art supply store or online supplier. Visit our website at fwcommunity.com.

19  18  17  16  15      5  4  3  2  1

DISTRIBUTED IN CANADA BY FRASER DIRECT
100 Armstrong Avenue
Georgetown, ON, Canada  L7G 5S4
Tel: (905) 877-4411

DISTRIBUTED IN THE U.K. AND EUROPE
BY F&W MEDIA INTERNATIONAL LTD
Brunel House, Forde Close, Newton Abbot,
TQ12 4PU, UK
Tel: (+44) 1626 323200, Fax: (+44) 1626
323319
Email: enquiries@fwmedia.com

DISTRIBUTED IN AUSTRALIA BY CAPRICORN
LINK
P.O. Box 704, S. Windsor NSW, 2756 Australia
Tel: (02) 4560-1600; Fax: (02) 4577 5288
Email: books@capricornlink.com.au

ISBN 13: 978-1-4403-3895-3

Edited by Mary Burzlaff Bostic
Designed by Geoffrey Raker
Production coordinated by Jennifer Bass

# ABOUT THE AUTHOR

Pam Carriker is an artist, instructor, author of books *Art at the Speed of Life* and *Creating Art at the Speed of Life*, and a columnist for *Somerset Art Journaling*. Born and raised in the Pacific Northwest, she now resides in the Dallas/Fort Worth, Texas, area with her husband and her youngest son, while her two oldest boys serve in the Army and National Guard. Traveling to teach around the country is something she enjoys very much, as sharing the satisfaction that comes from creating art is her passion. Pam's work and writing can be found in more than fifty publications, and she serves as a Director's Circle Artist for Stampington & Company. She has created instructional art journaling videos for Strathmore Artist Papers line of visual journals as well as designed a line of stencils for StencilGirl rubber art stamps for Stampington & Company. Pam also continues to develop her line of signature mixed-media products for Derivan Matisse. Turning her hobby into her dream job has been the culmination of a lifelong pursuit of living a creative life, and she firmly believes it is never too late to begin living Art at the Speed of Life! Visit Pam at pamcarriker.com or email her at pamcarriker@gmail.com.

# ACKNOWLEDGMENTS

Book number three only happens with the continued long-term support of those closest to you. Thank you to my dear husband for helping me get through the stressful times and for the support of my hobby-turned-career. Thank you to my youngest son who still lives at home and has to put up with "preoccupied Mom" at times, and to my two grown sons for checking in on me to see how it's going. You all are my rocks, and I wouldn't be doing this if I didn't have your loving support.

Thank you to team North Light for allowing me to create the book I envisioned and to Tonia Jenny for believing in it. A special thanks to my editor, Mary Bostic, for all of your help and for making this process so enjoyable.

# IDEAS. INSTRUCTION. INSPIRATION.

Receive FREE downloadable bonus materials when you sign up for our free newsletter at createmixedmedia.com.

Find the latest issues of *Cloth Paper Scissors* on newsstands, or visit clothpaperscissors.com.

# GET YOUR ART IN PRINT!

Visit **createmixedmedia.com** for up-to-date information on *Incite*, *Zen Doodle* and other North Light competitions.

 Follow Create Mixed Media for the latest news, free wallpapers, free demos and chances to win FREE BOOKS!

 These and other fine North Light products are available at your favorite art & craft retailer, bookstore or online supplier. Visit our websites at createmixedmedia.com and artistsnetwork.tv.